From Here to There

Published by
Princeton Architectural Press
37 East Seventh Street
New York, New York 10003

For a free catalog of books, call 1.800.722.6657.
Visit our website at www.papress.com.

Editor: Nicola Bednarek
Designer: Deb Wood and Bree Anne Apperley

Special thanks to: Nettie Aljian, Sara Bader,
Janet Behning, Becca Casbon, Carina Cha,
Penny (Yuen Pik) Chu, Tom Cho,
Carolyn Deuschle, Russell Fernandez,
Pete Fitzpatrick, Wendy Fuller, Jan Haux,
Linda Lee, Laurie Manfra, John Myers,
Katharine Myers, Steve Royal, Dan Simon,
Andrew Stepanian, Jennifer Thompson,
Paul Wagner, and Joseph Weston of
Princeton Architectural Press
 —Kevin C. Lippert, publisher

Library of Congress Cataloging-in-
Publication Data
Harzinski, Kris.
 From here to there : a curious collection
from the hand drawn map association /
Kris Harzinski. — 1st ed.
 p. cm.
 ISBN 978-1-56898-882-5 (alk. paper)
 1. Map drawing. 2. Maps—Collectibles.
I. Hand Drawn Map Association. II. Title.
 GA130.H336 2009
 912—dc22

 2009050898

FROM HERE TO THERE

A Curious Collection from the Hand Drawn Map Association

KRIS HARZINSKI

PRINCETON ARCHITECTURAL PRESS
NEW YORK

ACKNOWLEDGMENTS

The Hand Drawn Map Association wishes to thank everyone who has shared their work with us or helped to support our projects, with an extra special thanks to Harriet Hacker, Will Haughery, and Christian Herr for their unwavering dedication.

We would love to add your work to our collection. Please consider submitting your maps or diagrams to us at handmaps.org.

*Bernard Bonnet and Margo Handwerker, Obama 2008 Campaign Office in Houston, Texas,
Collection of the Hand Drawn Map Association*

PREFACE

The idea for the Hand Drawn Map Association (HDMA), an archive of maps and other diagrams drawn by hand, came to me while I was going through some boxes of old papers in preparation for a move. As I was sitting on the floor sorting papers and throwing others away, I came across a number of maps that people had drawn for me over the years. I had saved them for one reason or another, but never thought of them as a collection per se. As I looked at them then, the memories they represented were perfectly re-created in my mind. The maps had become much more than useful directions from one place to another; they had become accidental records of a moment in time.

This eventually inspired me to share these maps with others. I wanted people to see how these seemingly insignificant scraps of paper represented individual stories of people's lives, and how these simple drawings of a specific place held not just factual information, but personality as well. The HDMA began as a website where I posted the few maps I had collected with a simple invitation to others asking them to contribute their own maps, their stories, and their personal accounts of the places they've experienced out in the world.

Looking through the maps in my collection, I am always amazed at how the person drawing the map often inadvertently records specific details peculiar to a place. These can be linked to significant events, such as in this simple map to Barack Obama's campaign headquarters, scribbled on a napkin. In one sense, this particular map has become a document of his historic campaign for the presidency. Still others can be related to popular culture: a map noting things to see in Chicago (pages 48–49) includes the location of a now famously shuttered music venue, Lounge Ax. A map can also recall something completely mundane, such as a high school party in a Detroit neighborhood (pages 68–69), or trying to find a rental location for a U-Haul trailer (page 20). In a larger sense, these maps document people interacting with their environment. They record the human urge to travel, to discover new things, to venture off into unknown places just to see what's around the corner, to take road trips to Chicago, go scuba diving in the Bahamas, or bike

across the United States with a group of friends. They represent the power of mundane objects, of seemingly insignificant ephemera, to remind us of a larger human desire to keep a record, to remember, to travel, to wander, and to discover.

Very few maps resembling those in this collection have been intentionally archived throughout history. Most maps collected and preserved in archives around the world are more polished and refined, such as Abraham Lincoln's map of the town of Huron, Illinois, created in May 1836 (page 12). This official record was drafted by Lincoln, when he was a deputy surveyor, in order to provide a record of land purchased by John Kennedy Kincaid. An interesting exception, however, is Ernest Shackleton's quick sketch of Antarctica (pages 14–15). He drew the image on a menu card in 1914 for Clive Morrison-Bell at the London Devonian Association's annual dinner. It depicts the proposed route for his Trans-Antarctic Expedition. Another notable example is by Alexander Calder, who sent an invitation to fellow artist Ben Shahn in 1949 that included a map with directions to his home (page 13).

The collection of maps presented in this book is organized into six chapters based on recurring themes. "Direction Maps" is a series that represents the HDMA's original mission: to collect maps created in a natural and practical way to provide directions from one place to another. These maps are so utilitarian they often find their way not into a book or archive but directly into the trash, yet they offer a unique point of view on a particular place. You may find yourself in Philadelphia some day and Ryan Anderson's useful map of things to do in the city could be quite inspiring (pages 44–45). "Found Maps" includes not only the very first map in my collection, rescued from the trash in Glasgow long before the HDMA existed (pages 66–68), it also compromises a small number of maps other people have found in their daily lives. "Fictional Maps" is a collection of maps that document imagined and fictional realities such as Jamie McQuinn's map of Quastolia, a country for ants he developed as a child (pages 96–97). "Artful Maps" includes a variety of works that are more elaborate than other maps in the archive, or works that use cartography as a point of reference. A good example is Yumi Roth's project, *Meta Mapa*, where she invites people to draw maps on their hands that lead to interesting places in their city (pages 126–27). "Maps of Unusual Places" is a series of maps that document and diagram places not

normally thought to have topology or geography. It includes maps of the body (both for practical and metaphorical purposes), maps of the Internet, and even a map of trash found along the road. The last chapter, "Explanatory Maps," is a collection of maps that were not necessarily created to provide directions from one place to another, but are instead maps and diagrams drawn to tell a story or explain a particular concept. Jan Rothuizen's map of the Anne Frank House in Amsterdam (pages 175–77) combines a variety of narratives enacted within this architectural space. He recounts a personal story while addressing both the historic importance of the space and its importance as the most popular tourist attraction in the city.

Abraham Lincoln, Map of Huron, Illinois, Collection of the Abraham Lincoln Presidential Library and Museum

Alexander Calder, hand-drawn map to Ben Shawn, February 24, 1949 © 2010 Calder Foundation, New York/ Artists Rights Society (ARS), New York. Illustration courtesy of the Ben Shahn papers, 1879–1990, Archives of American Art, Smithsonian Institution.

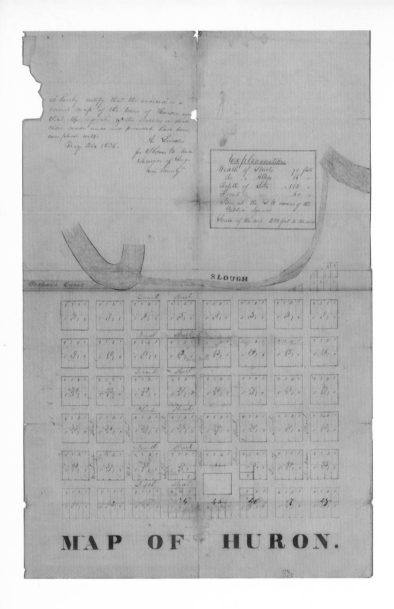

MAP OF HURON.

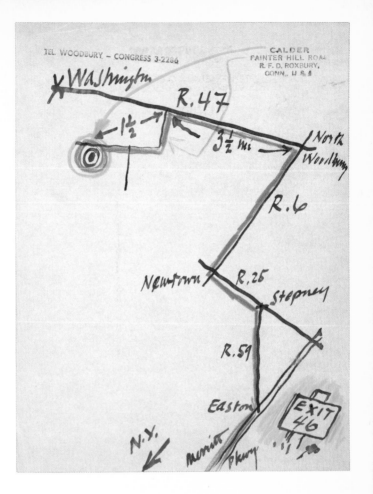

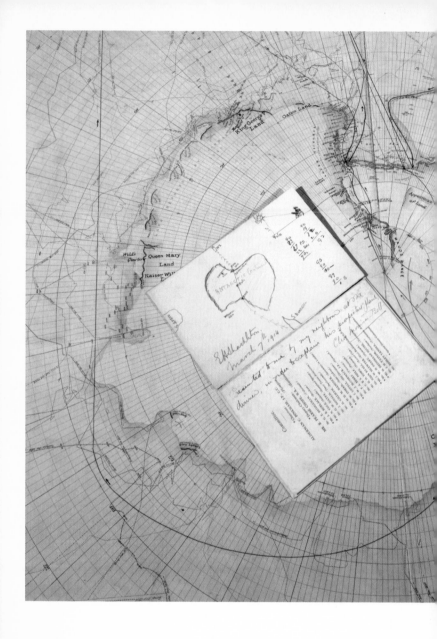

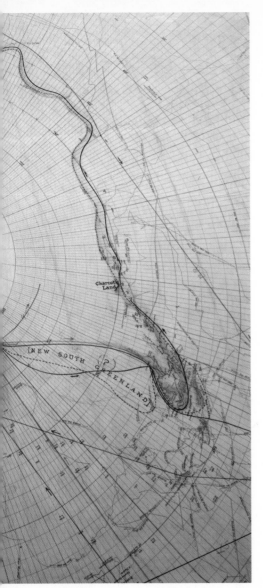

Ernest Shackleton, hand-drawn map by Shackleton featuring South Polar chart and showing routes of Shackleton, Stackhouse, Bruce, and Koing, Collection of the Royal Geographical Society © Royal Geographical Society

DIRECTION MAPS

LOST IN THE WOODS

SUE MARK

A few years ago Sue was living in Sofia, the capital of Bulgaria, working on creating an oral history of the city. Her partner came for a visit from California, and they rented a station wagon to set out to explore the Bulgarian countryside. Eventually, the car broke down and the two found themselves in Bansko, a ski town south of Sofia. They were referred to a man named Bicer, who let them stay at his guesthouse for five dollars a night. Sue writes:

> Bicer wanted to know our plans. We said we would love to explore the mountains and have a leisurely, but not strenuous, day hike. "No problem," he said, "I know just the route for you!" "But it has to be easy," I explained in Bulgarian, "nothing too hard." Bicer put his hand on my shoulder and said, "Even my grandmother could do this hike, my grandmother and her cow!" The next morning, he drew us this map and instructed us to meet him at the hotel Bistritsa at the route's conclusion. His words exactly were: "Enjoy yourselves, take your time, even go for a swim in the mountain lakes!" We followed all of his instructions to the letter, going so far as to take a nap on some hot slab rocks after our dip in the gorgeous glacier pools. As we were heading down the mountain, we noticed the sun beginning to set. Down and down we went, down and down the sun sank, and no sign of the hotel. Darkness was upon us, and panic threatened. We had no more food or water and no way of contacting anyone. After an unknown amount of time, we saw a fire in the woods, a group of guys, a small hut, and a jeep. I explained our situation, showed one of the guys our map, and he said one of the most oft heard Bulgarian expressions, "No problem!" He then assured me, "I know this hotel, and Bicer is my friend. I can take you there right now." I tried to ignore the fact that the gang was fiercely drunk and the road was no more than a rocky river bed. But we had no other option than to hop in the jeep, take a few swigs of rakia to soften the ride, and head down. The rest of the night is somewhat of a blur: Bicer was called to the hotel, and he was beside himself with fear and anger. "What, you didn't listen to me! I told you, you must reach the summit by lunchtime, no later, so that you can reach the end before dark!" I wanted to tell him that his map was crap—but my exhaustion depleted my Bulgarian, and I could tell that he was truly concerned for our safety. So instead, we stopped at the local store, and I bought him a bottle of whiskey. We all sat in his dining room, sipping hearty soup and toasting the hike, already creating legends from our misadventure.

BANSKO, BULGARIA

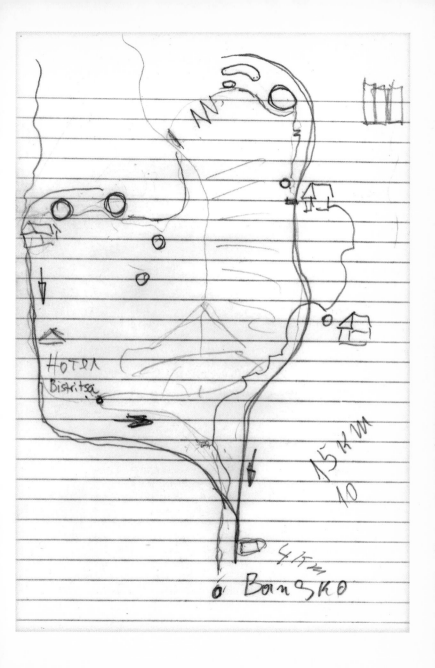

HOTEL
Bistritsa

15KM
10

4km
Bangko

↑ U-HAUL
DROP-OFF

TONY GONZALEZ

Tony and his fiancée recently moved to a new town in Virginia. They rented a U-Haul trailer to transport all of their belongings. Once in town and unpacked, they took it to a small mechanic's shop. Although the shop could not accept the trailer, the owner drew them this map to the correct drop-off point. It was not much, but it did its job.

WAYNESBORO, VIRGINIA

DIG →

MARTIN HEES

This map was created for students participating in an archaeological dig in northwest France. The map documents the area around the villages of Glomel and Trégornan as well as the excavation site and the complicated route to the small farm where the group was staying. Some of the features on the map include *calvaires* (stone roadside crosses) along a few of the roads, *poubelles* (dustbins) marking a crucial turn in the journey to avoid a maze of back roads, a *grille* (steel grid fence), and *sangliers* (wild boars) that roamed free on the farm land.

GLOMEL AND TRÉGORNAN, FRANCE

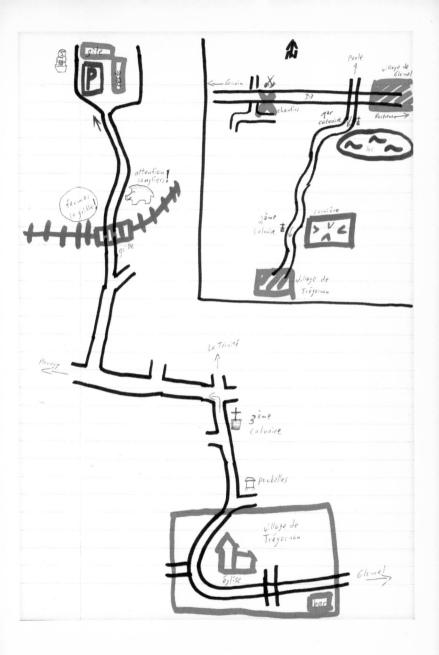

WILLIAMSBURG TO PENN STATION

JAMES MAXWELL

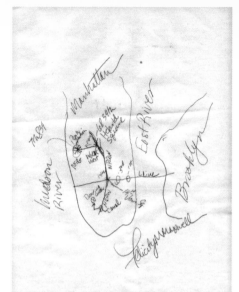

James's son and daughter-in-law drew these two maps for him when he was visiting them in Williamsburg, Brooklyn. When James was leaving to return home, he used the maps to help him find his way to the Amtrak section of Penn Station in Manhattan, several subway stations away.

The small map provides a general orientation of Manhattan, Brooklyn, and the surrounding area. The other map explains the connection James was to make between the L train and the N. He was directed to get in the middle car of the L train so that when he got off at Fourteenth Street/Union Square, he would be in the right place to get on the last car of the N train, putting him in position to easily find the Amtrak area of Penn Station. It did not work out quite as planned, however. James did get on the right trains, but did not get the cars right. Rather than simply walking up a flight of stairs, he had to wander around Penn Station to find the right place.

NEW YORK CITY, NEW YORK

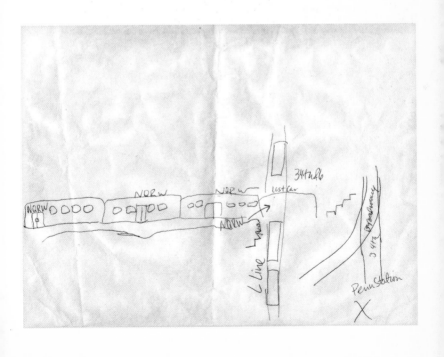

DIRECTION MAPS

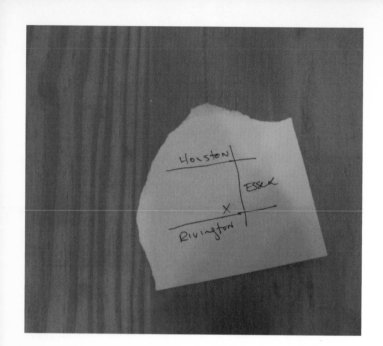

↑ LOWER EAST SIDE

MATTHEW RODRIGUEZ

Matthew sometimes creates small maps like this one for himself, as he often gets lost in Manhattan's Lower East Side, despite having lived in New York for years.

NEW YORK CITY, NEW YORK

↓ VISIT ME

JEAN-LUC DIDELOT

Jean-Raymond Dupré drew this map for Jean-Luc in 1993 when the two met in Pondicherry, India. The map shows the route to Jean-Raymond's house in France so that Jean-Luc could visit him at some point in the future. "S.P." and "R," both circled on the map, represent the cities of Saint-Pons and Riols. The squiggly line going north of Riols is a mountain road filled with curves that passes a triangular road sign. The final destination, indicated with a "T," represents Jean-Raymond's home.

TARBOURIECH, FRANCE VIA PONDICHERRY, INDIA

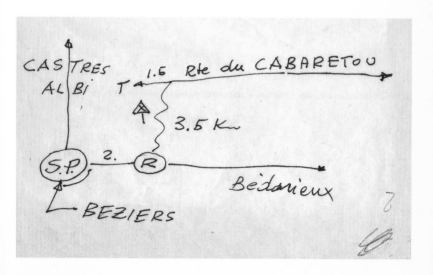

BRITTANY SHOOT

Brittany used this map in the spring of 2009 to attend an animal rights protest in Copenhagen. A local retailer was selling garments made of imported fox pelts, which are illegal in Denmark. Protesters stood outside in the shopping area for several hours over a period of weeks, holding up banners and handing out leaflets. To walk to the protest, one would weave past several department stores, including Illum and Magasin.

COPENHAGEN, DENMARK

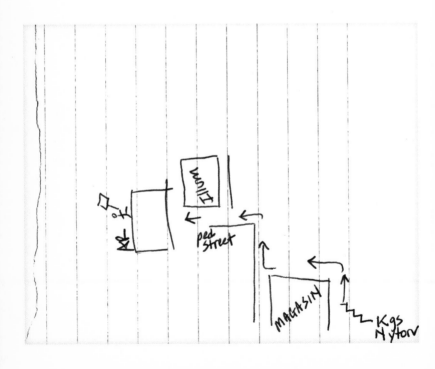

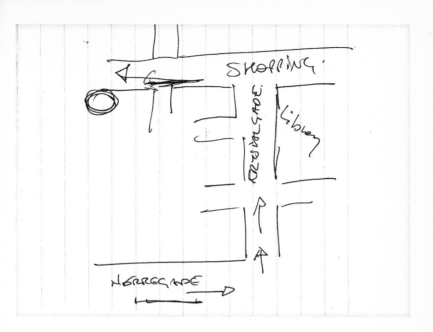

↑ YOGA MAP

BRITTANY SHOOT

This map was drawn for Brittany by her acupuncturist, Camilla. It provides simple directions from her practice on Nørregade to a nearby yoga studio in inner Copenhagen.

COPENHAGEN, DENMARK

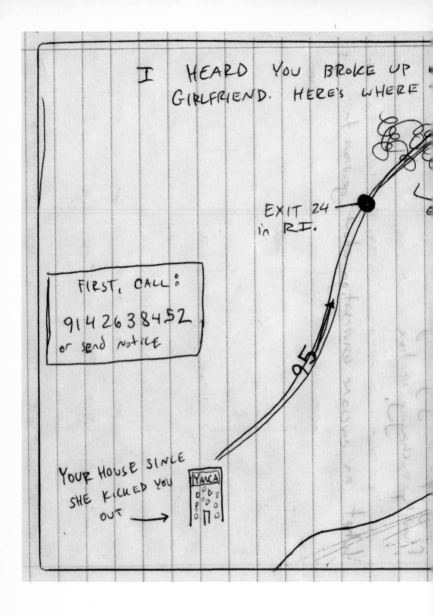

I HEARD YOU BROKE UP WITH YOUR GIRLFRIEND

LOLA PELLEGRINO

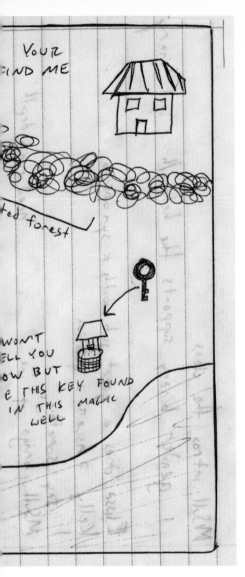

Your

FIND ME

ted forest

WON'T
TELL YOU
HOW BUT
GET THIS KEY FOUND
IN THIS MAGIC
WELL

Lola drew this map to document the end of an era in her life. When her ex-boyfriend broke up with his then-girlfriend—a girl with whom Lola did not really get along with—she drew the map to let him know that she was still around if he needed a friend or wanted to hang out. Unfortunately for Lola, the reference to living at the YMCA, intended as a joke, offended her ex and gave her nemesis fuel for a rather caustic discussion that followed.

RHODE ISLAND

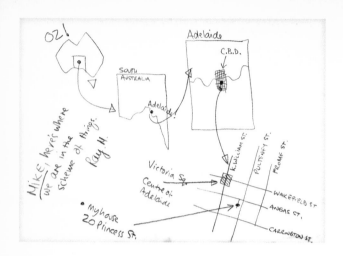

↑ WHERE WE ARE

RAY MARCHANT

Ray drew this map for an English
friend to help him find his way when
making a trip to Ray's house in
Adelaide. The map assumes his friend
can figure out how to get to Australia,
but from there it provides a series
of increasingly more detailed steps
to point out the final destination in
Adelaide.

ADELAIDE, AUSTRALIA

↓ POLYTECHNIQUE

MARCUS AURIN

This map was created for Marcus when he asked for directions in a Paris Metro station. He had just gotten off the train from Charles de Gaulle Airport and was on his way to visit a friend whom he had not seen for years. All he had was her street address and the arrondissement, so he asked a nearby woman if she knew where the Rue de l'École Polytechnique was. She simply smiled, turned to her friend for a pen and paper, and proceeded to draw this map. Marcus had no trouble following her directions and was so impressed with the woman's map that he has kept it ever since.

PARIS, FRANCE

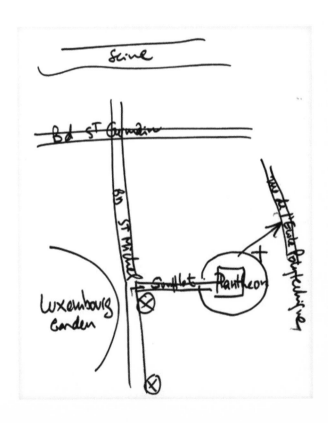

↓ C.L.U.I. ROVER

RICHARD SAXTON

Matt Lynch, a member of the artist
collective Simparch, drew this
map for Richard while they were
sitting at California Tacos & More
in Omaha, Nebraska. It provides
directions to the *C.L.U.I. Rover*, a
pedal-powered portable research
station created by Richard and the
municipalWORKSHOP as part of
Simparch's *Clean Livin'* project. *Clean
Livin'* is a sustainable facility for the
Center for Land Use Interpretation's
artist-in-residence program. The team
reclaimed a site on a remote part of
America's largest World War II airbase
to provide a live/work space for
artists and researchers participating
in the program.

WENDOVER, UTAH

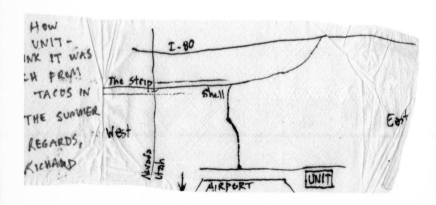

↑ TONY'S MOM'S MAP

CHASE PURDY

This map was drawn for Chase by a friend's mother. Chase drove to Chicago to see the White Sox and later visited his friend Tony Gonzales in northern Illinois. On the way to the Gonzalez household he missed his exit, taking a much longer route to his destination. Tony's mother drew this map to show Chase how to get from their house through the city of Chicago and onto Interstate 80/90.

CHICAGO, ILLINOIS

↓ FELLOW PASSENGER BECOMES FRIEND

DAVID LITTMAN

This map was drawn for David by his seatmate, Peter, on a flight from Frankfurt, Germany, to Vienna, Austria. Peter wanted David and his wife, Kim, to experience as much as possible during a seven-hour layover in Vienna. The city was decorated for the Christmas season, and the map was intended as a guide to the various sights and places to eat. Peter eventually decided to take the day off and to show the couple around the city together with his wife.

VIENNA, AUSTRIA

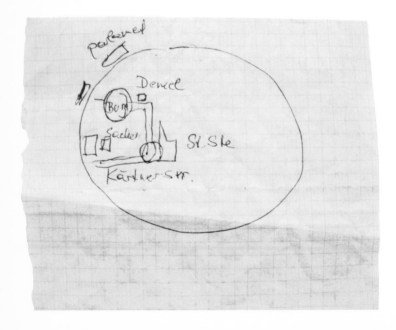

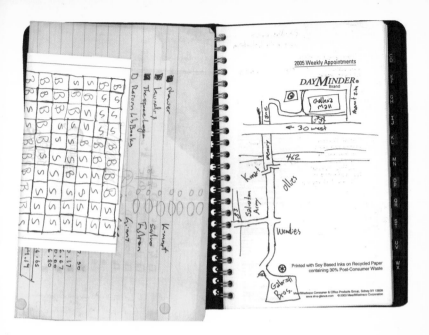

↑ CHEAP STUFF

SHALYA MARSH

Denise Legrand drew this map on the first page of Shalya's planner to explain where to find cheap stuff in York, Pennsylvania. On the map are local favorites, Ollie's and Gabriel Brothers, both specializing in selling surplus merchandise, as well as the Salvation Army. You can also glean a slice of Shalya's daily life from her day planner.

YORK, PENNSYLVANIA

HOW TO FIND NUSA DUA

JEFF WERNER

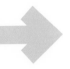

This map was drawn for Jeff by an expat in the fall of 2007 and explains how to get from the middle of Bali to Nusa Dua at the island's edge. Jeff writes:

> Everyone gets around Bali on a motorbike by feel. The only thing to distinguish every rice field and little store from every other field and store that blanket the island is by the major roundabouts with epic Hindu statues in their centers. If you are lucky enough to find a street sign, it would be in Indonesian, with unrecognizable names to a foreigner.

BALI, INDONESIA

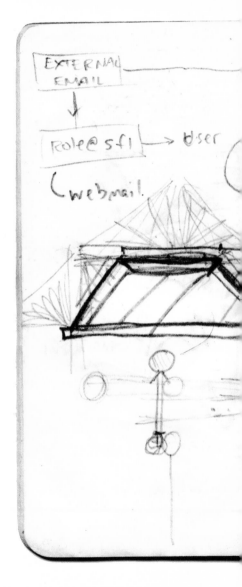

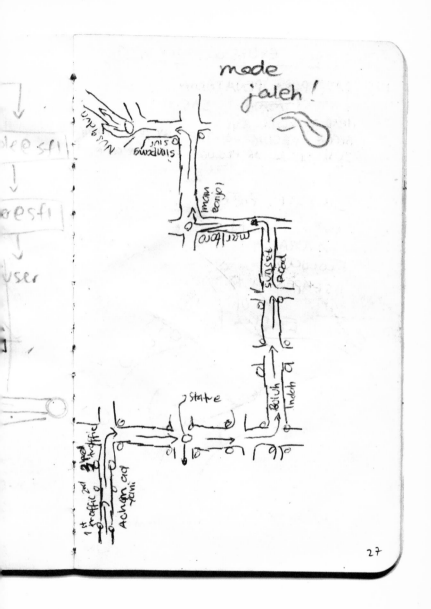

DAMAGED → VIDEOS

RENEE SHARP

This incredibly vague map to a sushi restaurant was made for Renee and her boyfriend by a video store clerk. The clerk drew with a Sharpie marker on a slip of paper used for customers to report problems with their video rentals. The map was, in fact, so vague that it did not direct the couple to the restaurant, though they got there eventually. Later, the map became a favorite bookmark circulating back and forth between the books Renee and her boyfriend were reading.

SAN ANSELMO, CALIFORNIA

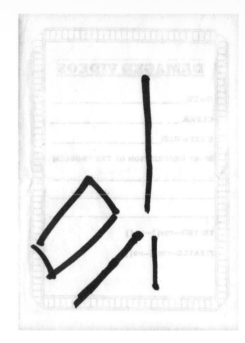

DAD'S MAP TO ↓ RISD

EILEEN M. FLANAGAN

Eileen's father drew this map to help her find her way to the Rhode Island School of Design (RISD) in downtown Providence.

PROVIDENCE, RHODE ISLAND

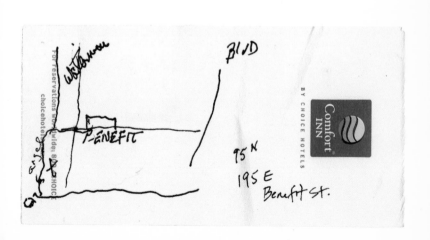

FWM VIP PARTY

* MAP IS NOT TO SCALE

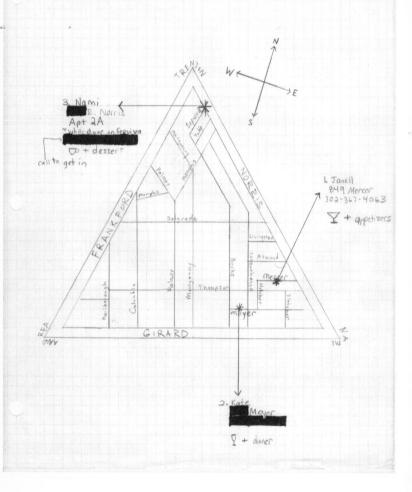

N
W — E
S

TRENTON

3. Nami
E. Norris
Apt 2A
* white door on Sepviva
☕ + dessert

call to get in

Sepviva
Tulip
mechanics
Memphis

Palmer
memphis

NORRIS

FRANKFORD

Belgrade

Livingston
Almond
Ruthberland
Berks
kitchen
Fletcher

1. Janell
849 Mercer
302-367-4063

🍸 + appetizers

Mercer

Palmer
Montgomery
Thompson

Marlborough
Columbia

REA

GIRARD

VNA

Moyer

2. Kate
Moyer

🍷 + dinner

← FWM VIP PARTY

JANELL OLAH

Janell created this map in 2007
for a progressive party held for
the apprentices at Philadelphia's
Fabric Workshop and Museum. The
map indicates her neighborhood
in Fishtown with three different
locations partygoers visited
throughout the evening.

PHILADELPHIA, PENNSYLVANIA

↓ MAP TO NEIGHBOR'S HOUSE

NEAL RESSLER

Neal created this map to his
neighbor's house mostly as a joke.
The simple map explains how to
get from 9 South Maple Avenue to
11 South Maple Avenue. Among his
friends, Neal is well known for his
map-making abilities, and they often
ask him to draw maps to local points
of interest in Pennsylvania.

LEOLA, PENNSYLVANIA

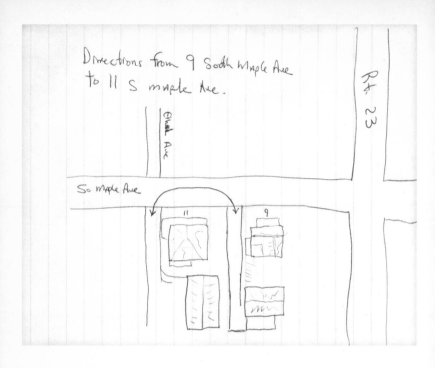

Directions from 9 South Maple Ave to 11 S maple Ave.

Oak Ave

Rt. 23

So Maple Ave

11 9

LANCASTER TO PEQUEA CREEK

NEAL RESSLER

This map by Neal provides detailed directions from the city of Lancaster, Pennsylvania, to a hiking trail near Pequea Creek a few miles south of Willow Street, Pennsylvania.

LANCASTER COUNTY, PENNSYLVANIA

Neal Ressly

Lancaster to
Pequea Creek

Lancaster

Ange St.

New Danville Pike

S 272 / 222

222 S

Long St.

Willow St.

272 S

Brullosville RD

Pensy RD

Tunnel

324

PARK
Here
Trail By
Creek

Railroad
Br.

River RD.

Pequea Creek

River RD.

I'M GOING
TO WORK

RYAN JAMES ANDERSON

Ryan drew this map for a friend who was visiting him in Philadelphia in order to encourage him to go out and do things during the day while Ryan went to work. It includes standard Philly attractions such as the Rocky steps, where Sylvester Stallone's character famously runs up the steps of the Philadelphia Art Museum (as do many tourists), as well as Pat's and Geno's steaks, and the Mutter, a medical oddities museum.

PHILADELPHIA, PENNSYLVANIA

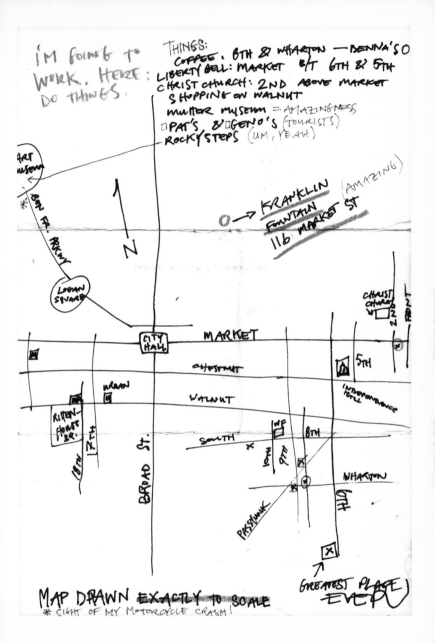

I'M GOING TO WORK. HERE: DO THINGS.

THINGS:
COFFEE: 8TH & WHARTON — BENNA'S O
LIBERTY BELL: MARKET B/T 6TH & 5TH
CHRIST CHURCH: 2ND ABOVE MARKET
SHOPPING ON WALNUT
MUTTER MUSEUM = AMAZINGNESS
□ PAT'S & □ GENO'S (TOURISTS)
ROCKY STEPS (UM, YEAH)

ART MUSEUM
* BEN FR. PKWY
LOGAN SQUARE

N

→ FRANKLIN (AMAZING)
FOUNTAIN
116 MARKET ST

CHRIST CHURCH
2
N
FRONT

CITY HALL MARKET

CHESTNUT 5TH

ARAN WALNUT INDEPENDENCE HALL

RITTEN-HOUSE SQ. SOUTH WF 8TH
18TH 17TH 10TH 9TH X

BROAD ST. PASSYUNK X W WHARTON 6TH

X

GREATEST PLACE EVER

MAP DRAWN EXACTLY TO SCALE
* SIGHT OF MY MOTORCYCLE CRASH!

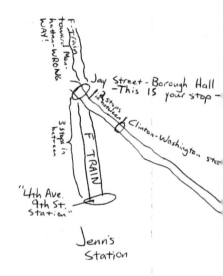

F Train
toward Man-
hattan-WRONG
WAY!

Jay Street - Borough Hall
—This IS your stop—

2 steps
in between

Clinton-Washington st...

3 steps in
between

F TRAIN

"4th Ave.
9th St.
Station"

Jenn's
Station

NOTE: When you come
back you'll take the
LIRR to the Jamaica
Station, then to the Airtrain
@ JFK.

CHAD'S MAP TO JENN

CHAD MULLEN

Chad made this map for a friend who went to visit their mutual friend Jenn in Brooklyn. The map was never meant to stay around, but Jenn, a graphic designer, liked it so much that she kept it.

BROOKLYN, NEW YORK

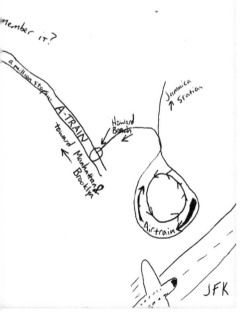

sfer to (F TRAIN)

member it?

a million stops

A-TRAIN

toward Manhattan & Brooklyn

Howard Beach

Jamaica Station

Airtrain

JFK

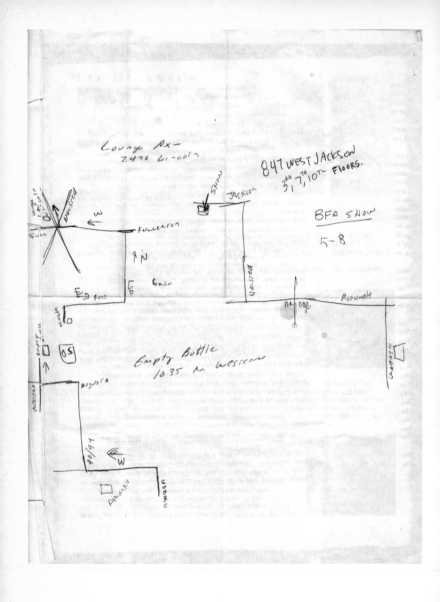

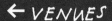

← VENUES

KRIS HARZINSKI

Kris used this map in the summer of 1998 when he was visiting Chicago. It includes three locations that the map drawer encouraged him to visit: two music venues, Lounge Ax and Empty Bottle, and the School of the Art Institute of Chicago's Bachelor of Fine Arts exhibition. He made it to the BFA show, which consisted of a multilevel warehouse filled with hundreds of works by art students, and the Lounge Ax, which closed in 2000.

CHICAGO, ILLINOIS

↓ HOME TO CABIN

SHALYA MARSH

Shalya's friend Dean Fenley drew this map for her when she and her husband, Jeffrey Moser, were on vacation in Georgia in the summer of 2004. It shows how to get from Dean's home in Decatur to his mountain house deep in the north Georgia woods. Also described on the map is the way to Moto Bravo, a great scooter shop in Atlanta, and, if you look closely, you might find the famous spaghetti junction of the Tom Moreland Interchange, the Fox Theatre, downtown Decatur, a giant elephant statue, a horse farm, and even a nudist colony.

DECATUR, GEORGIA

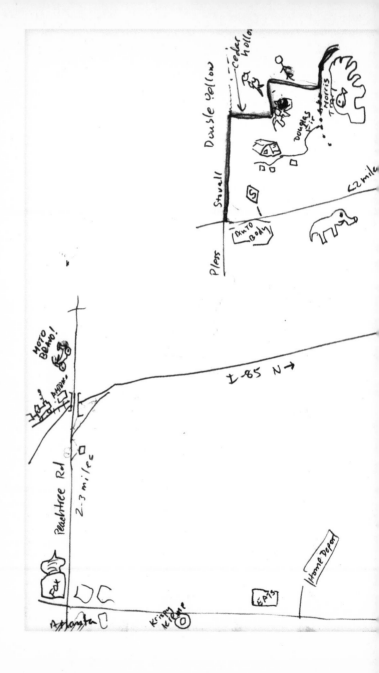

DIRECTION MAPS

BIKE MAP OF WEDDING

MARTIN VOORHORST

Martin got this great map from a
friend who works in a hotel in Berlin.
He was touring the city on bike and
used the highly detailed map to
navigate the Wedding District.

BERLIN, GERMANY

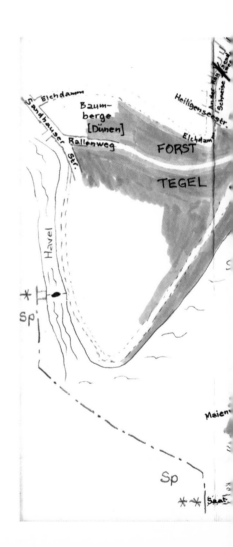

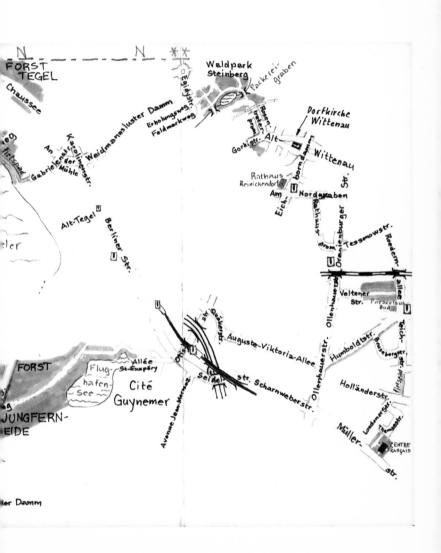

DIRECTION MAPS

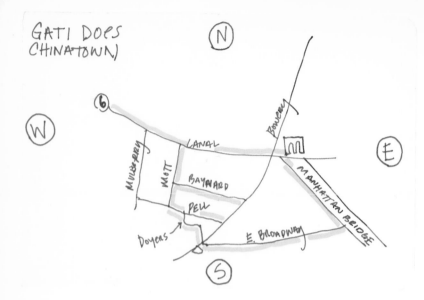

↑ GATI DOES CHINATOWN

NICHOLAS HUNT

Nicholas drew this map of New York's Chinatown with the intent to lead an out-of-towner through some of the neighborhood's more intriguing parts, starting from the 6 train's Canal Street subway stop. Unfortunately, the traveler took the wrong train and ended up in Brooklyn instead.

NEW YORK CITY, NEW YORK

DIRECTIONS →

SCOTT GRIFFITH

Scott's map shows how to get from Interstate 5 to his house on Ethridge Avenue. It also offers an alternate way, in dashed lines, for those who choose to take the waterfront route. Scott decided to make the map a bit more interesting by adding classic features such as the Unexplored Realm (to the west, of course), a sunken ship, and a buried treasure.

OLYMPIA, WASHINGTON

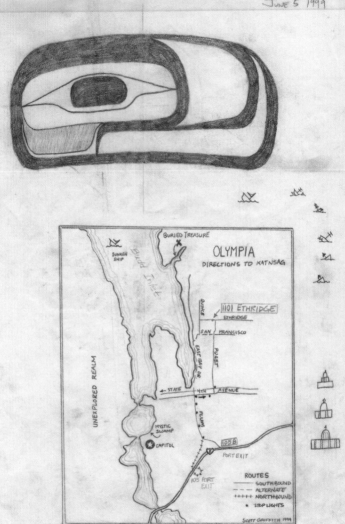

JUNE 5 1999

OLYMPIA
DIRECTIONS TO KATNSAG

BURIED TREASURE

SUNKEN SHIP

Budd Inlet

1101 ETHRIDGE

ETHRIDGE

SAN FRANCISCO

QUINCE

PUGET

EAST BAY DR

STATE ← → 4TH AVENUE

UNEXPLORED REALM

PLUM

MYSTIC SWAMP

CAPITOL

105 B

PORT EXIT

105 PORT EXIT

ROUTES
—————— SOUTHBOUND
- - - - - - ALTERNATE
++++++ NORTHBOUND
• STOP LIGHTS

SCOTT GRIFFITH 1999

BUS ROUTE:
4:40 72 TO TRANSIT TUNNEL BAY C
5:19 18 FROM 1ST & PINE

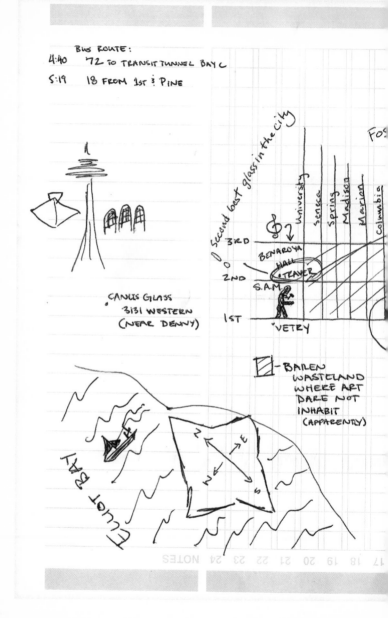

CANLIS GLASS
3131 WESTERN
(NEAR DENNY)

Second best glass in the city

3RD
BENAROYA HALL
2ND TAVER
S.A.M.
1ST VETRY

University
Seneca
Spring
Madison
Marion
Columbia

FOS

☐ — BAILEN
WASTELAND
WHERE ART
DARE NOT
INHABIT
(APPARENTLY)

ELLIOT BAY

N
W E
S

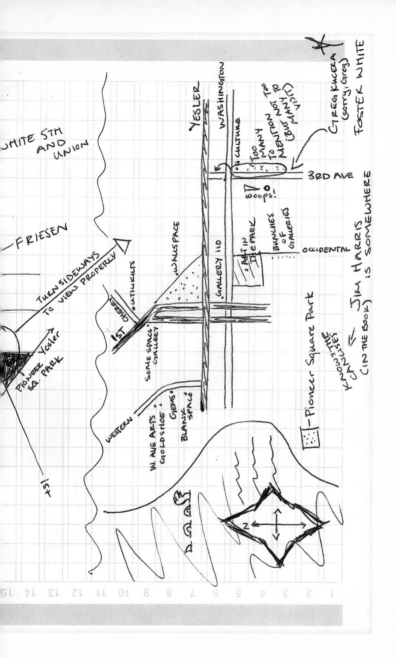

WHITE 5TH AND UNION

— FRIESEN

TURN SIDEWAYS TO VIEW PROPERLY

Pioneer Yesler Sq. Park

4 ST

Pioneer Sq. Park

CHEAP

UTIKELTS

1ST

SOME SPACE GALLERY

WN SPACE

WESTERN

WN AVE ARTS GOLD SHOE , GEMS , BLANK SPACE

GALLERY 110

ART IN THE PARK

BUNCHES OF GALLERIES

Yesler

WASHINGTON

4 CULTURE

TOO MANY TO MENTION NOT TO (BUT MANY TO VISIT)

WOOPS!

3RD AVE

OCCIDENTAL

GREG KUCERA (sorry, Greg)

FOSTER WHITE

— Pioneer Square Park

KNOWS THE CANALISET (IN THE BOOK)

JIM HARRIS IS SOMEWHERE

🔲 — Pioneer Square Park

N

2

↑ ARTWALK

WILLIAM HYMAN

William drew this map to help him
and his friend Courtney find various
locations during Seattle's First
Thursday Art Walk. As he notes, the
"three bizarre structures on the left
side of the map" are the Key Arena,
Space Needle, and the Pacific Science
Center. Also featured are Jonathan
Borofsky's *Hammering Man* at the
Seattle Art Museum (S.A.M. on the
map) and cardinal directions in the
form of islands floating in the water.

SEATTLE, WASHINGTON

COUCH SURFING →

KRISTA SHAFFER

Krista's roommate, Lauren Coco,
drew this map to help a couch surfing
couple who were staying with them
find the subway. A few days later,
someone found the map lying on
their table and decided to color it in
with markers.

PHILADELPHIA, PENNSYLVANIA

DIRECTION MAPS

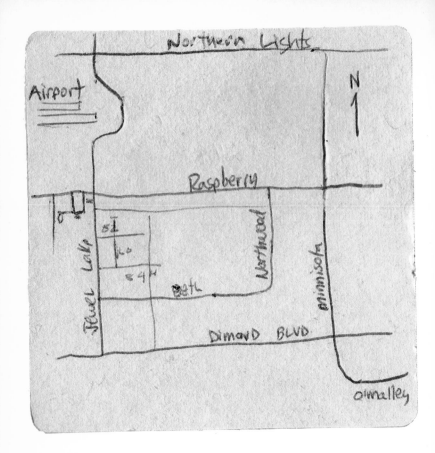

↑ COASTER

SCOTT GRIFFITH

Scott drew this map of Anchorage on a coaster while having a conversation at a local bar. "Northern Lights" at the top of the drawing refers to a street called Northern Lights Boulevard, not the polar lights you can sometimes see in the city.

ANCHORAGE, ALASKA

↓ DINNER AT A FRIEND'S

SPENCER BLACKMAN

Spencer used this map of Boston's downtown area to guide him from his workplace to a friend's house for dinner. He was on foot and planned to stop along the way and to detour from the direct route. He used the "T" symbols of subway stations as landmarks, as well as two well-known sites, Boston Common and Faneuil Hall.

BOSTON, MASSACHUSETTS

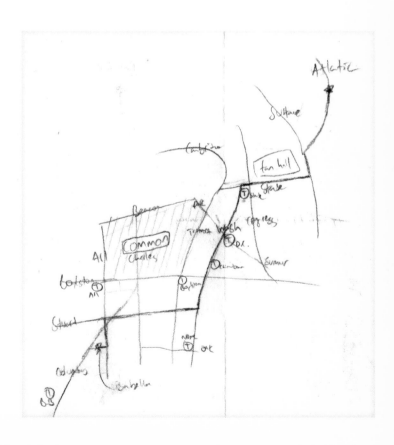

PROJECTS

STEFAN SAGMEISTER, JOE SHOULDICE, AND LEE WILSON

Sagmeister Inc. created this map for Columbia University's Graduate School of Architecture Planning and Preservation to document the school's various projects around the world. The accompanying sketch reveals the process of designing the map. At one point various modes of travel were considered as potential iconography.

VARIOUS LOCATIONS AROUND THE WORLD

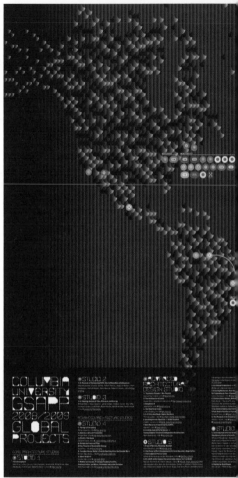

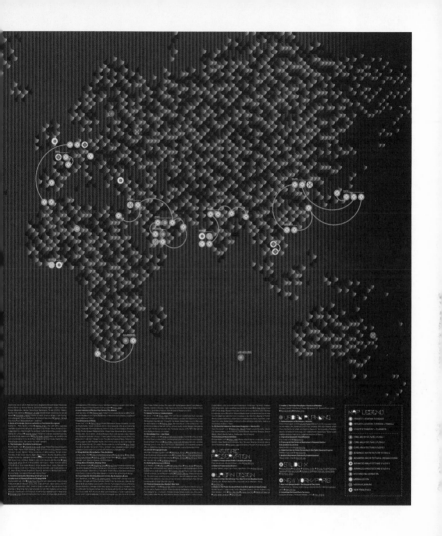

FOUND MAPS

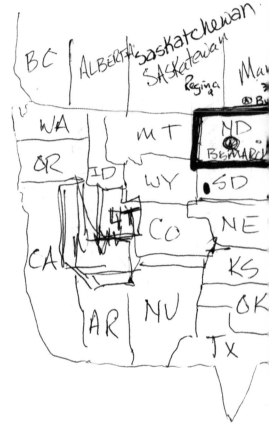

BC | ALBERTA | Saskatchewan
SASKatawan
Regina
Ma...

WA | MT | ND
Bismarck
OR | ID | WY | SD
MT | CO | NE
CA | | KS
AR | NU | OK
TX

LOCATION

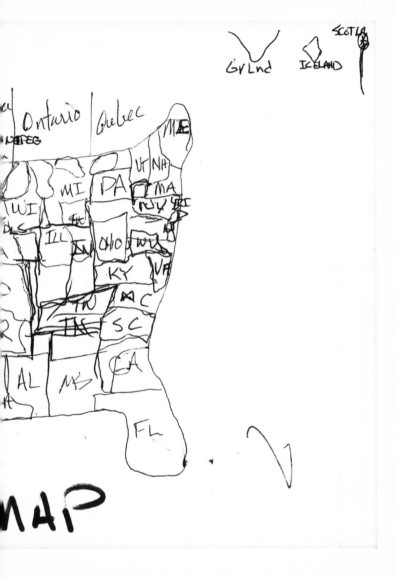

GrLnd

ICELAND

SCOTLA

Ontario | Quebec

WPEG

ME

UT NH

MI PA MA

WI NY

ILS

ILL OHIO WV

KY VA

TN NC

IN SC

AL MS GA

FL

MAP

↑ LOCATION MAP

KRIS HARZINSKI

From April 1 to April 9, 2000, the World Curling Championships were held at the Braehead Arena in Glasgow, Scotland. Kris had traveled there with his father Terry, who was promoting the 2002 World Curling Championships, which were to take place in Bismarck, North Dakota. Kris found this map in a trash can near the arena. The map, although not entirely accurate, was apparently used to help explain the location of North Dakota within the United States. Canada won both the men's and women's championships in Scotland that year.
UNITED STATES

BIG PARTY! →

STEFFANIE SAVINE

Steffanie's roommate Joel found this map when he was repairing ductwork in his eighty-two-year-old house just outside of Detroit. While working one afternoon, Joel was surprised to find a wallet hidden on top of one of the ducts. The wallet belonged to a high school student who used to live in the house. Inside the wallet, Steffanie and Joel found his photo ID card for Ferndale High School, a pay stub (indicating he made $2.50 per hour), a certificate for a record club, a copy of his birth certificate, and a few other scraps of paper, including this map to a "Big Party!" drawn on a sheet of paper from a day planner dated June 19, 1978. Steffanie later tracked down the wallet's owner through the Internet and returned it to him.
DETROIT, MICHIGAN

MONDAY

BIG
PARTY!

1978		JUNE				1978
SUN	MON	TUE	WED	THU	FRI	SAT
« »	« »	« »	« »	1	2	3
4	5	6	7	8	9	10
11	12	13	14	15	16	17
18	19	20	21	22	23	24
25	26	27	28	29	30	« »

JUNE

19

1978

WOODWARD

1mile

Hilton

WANDA

TROY

saratoga

Time 6:00 PM — ?

2/9/09.

Hi Kris –

HERE IS ANOTHER MAP. I FOUND THIS IN THE UNDERPASS TUNNEL NEAR THE CAL. AVE CALTRAIN STATION. IT IS FOR AN AREA OF PALO ALTO, CA. TRANSLATING:

"APPLE FIX" = APPLE REPAIR STORE

FRYS ELECTRONICS

FRYS

EL CAMINO

BIKE PATH

MATADERO

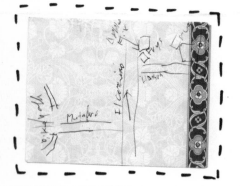

CHEERS –
Scott Witthoft.

← ↓ TRANSLATED MAP

SCOTT WITTHOFT

Scott found this map lying on the ground in an underpass tunnel. He includes a translation of the map, indicating the various features depicted, including an Apple repair store and Fry's Electronics.

PALO ALTO, CALIFORNIA

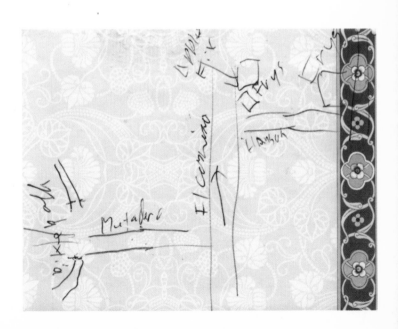

Isaac's

Queen Street
← Stores →

Market Central
Mark

Orange St.

Ice Cream
Shop

Prince Street.
←

Art Galleries .

DOWNTOWN

DAN RICCA

Dan found this map on a table at Isaac's, a popular sandwich restaurant in downtown Lancaster, Pennsylvania. The drawing depicts a one-block area around the restaurant. Also indicated are the popular Central Market, the oldest indoor farmer's market in the United States, and Lancaster's art gallery district. These are popular attractions in one of America's oldest tourist destinations.

LANCASTER, PENNSYLVANIA

S
t
o
r
e
s.

King Street

ce Street
afe

LITTLE MAP

ELOIS WARREN

Elois found this map folded in half while walking with a friend in the Russian Hill neighborhood of San Francisco. She picked it up hoping it was a love note but instead found a curious map with an airplane drawn on it. It is unclear what the map may have been used for, but it was found far from the area it depicts.

SAN FRANCISCO, CALIFORNIA

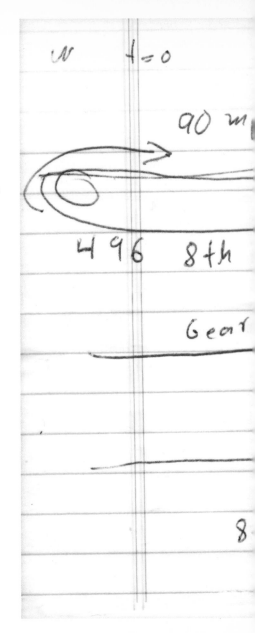

& Anza

Stanyan
Parker

Anza

FICTIONAL MAPS

ALPHISTIA

Tony Skaggs

This is an early map of Alphistia, a place Tony invented in 1967, when he was nine years old and lived in Newport, Kentucky. Tony describes Alphistia as a "neighborhood nation" where various houses on his street were designated as provinces and children from the area joined up as citizens. Tony and his friends even created an Alphistian alphabet and language. The country essentially existed in his backyard as a series of small buildings until 1973 when his mother asked that they be removed for a swimming pool. Once the actual physical location was destroyed, Tony continued to imagine his country on paper. This road map, drawn in 1977, when Tony was in college, is one of the earliest surviving maps of Alphistia. At the time, he envisioned the country being founded out of a cataclysmic event that destroyed life as we know it. The new country of Alphistia was located in the vicinity of Cincinnati, Ohio, its boundaries inspired by the shapes of European countries, especially postwar Poland.

ROAD MAP OF ALPHISTIA

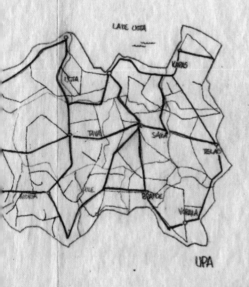

1977

99.85 km.
hard surfaced roads

153.4 km.
semi-surfaced roads

LAKE USTA

KARAS

USTA

TAWA

SAKA

TELAS

AGUA

ANLE

BANDE

VIRNA

UPA

ROAD SYSTEM

 hard surfaced road

 semi-surfaced road

WYSPY IDAIQUE

MARCIN SIEHANKIEWICZ

Marcin, a philologist and art historian
from Poland, drew this map when
he was around twelve years old. It
depicts a complex archipelago of
numerous small islands, whose shape
was influenced by southern Chile and
the coast of Norway. The place names
are all imaginary (mostly French-
influenced) while the descriptions are
written in Polish.

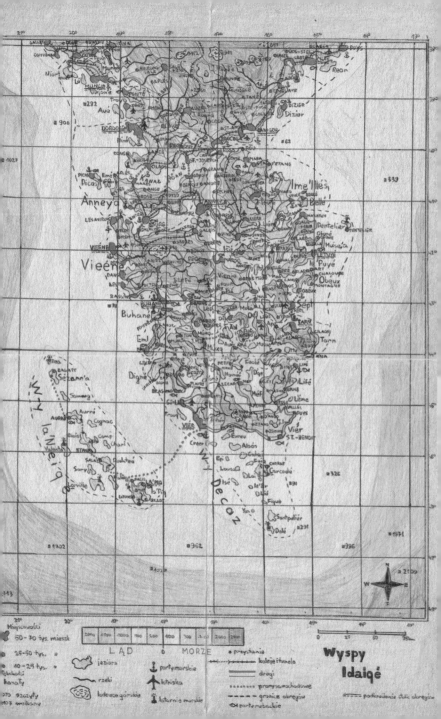

Wyspy
Idaiqé

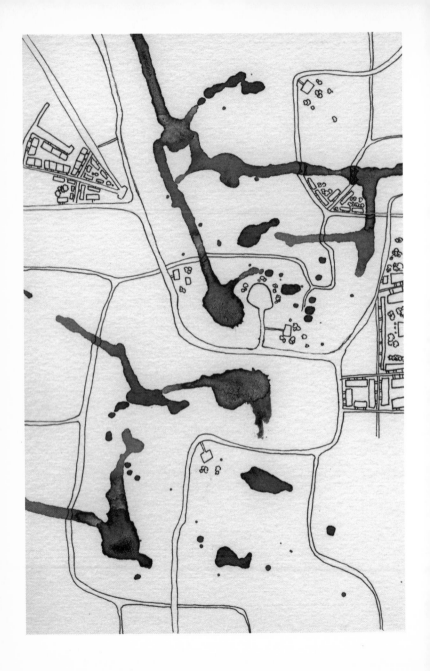

COASTAL →

CITIES

ERIC JONES

Eric is a student who likes to draw maps while listening to lectures. This map began in his notebook as a small town and, over the course of a series of lectures, grew into two large cities. The double lines represent interstates; the short, repeated lines stand for hills and mountains; and the open spaces depict water.

← INK MAP

EMILY GARFIELD

Emily created this map by first dripping ink on paper to create bodies of water. She then imagined how the area might be developed into a series of towns with interconnecting roads. She included a way to get out, but the roads that run off the page have no destination. Her process is logical, as the placement of the water determines the structure of the cities. People live near the water, and where there is no water, they build roads.

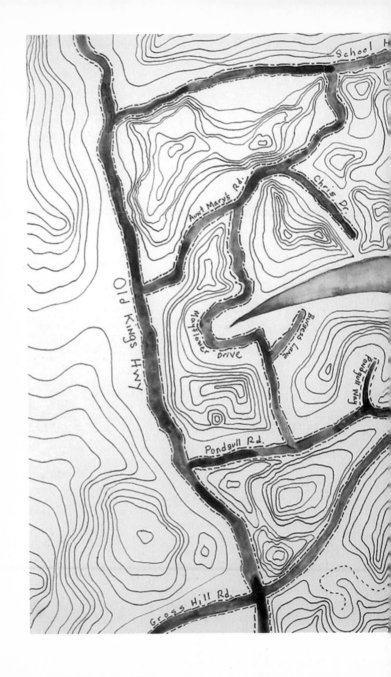

FICTIONAL MAPS

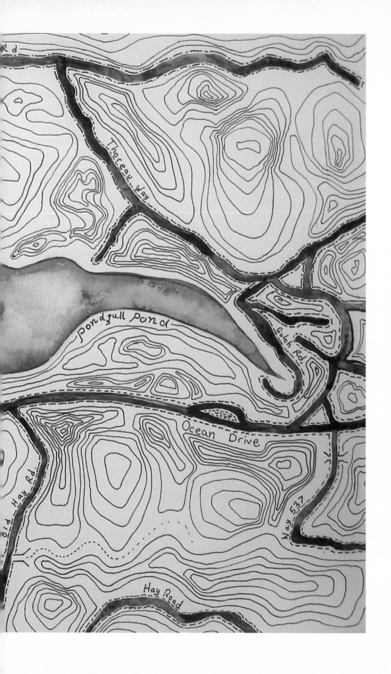

FICTIONAL MAPS

↑ PONDGULL POND

CLIFFORD EBERLY

Clifford's map shows a fictional body of water called Pondgull Pond. The pond's orientation and some of the road names are based on the area surrounding Gull Pond in Wellfleet, Massachusetts. The idea for the pond originated when Clifford and his friend went swimming in Gull Pond and wondered why gulls that congregated near freshwater lakes were not called pondgulls instead of seagulls.

NEWFOUNDLANDS

ELEANOR DAVIES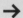

Eleanor created this map to explain a recurring dream to her friends. In the dream she wanders along the coastline of an island, attempting to reach the beginning, only to find the island is constantly morphing and stretching into a never-ending expanse of land. As she worked on the map, she realized the drawing continued to get bigger and bigger, much like the land formation in her dream. Eventually, the map reached a point where there was no clear distinction between the land and the water, increasing the sense of confusion and disorientation.

FICTIONAL MAPS

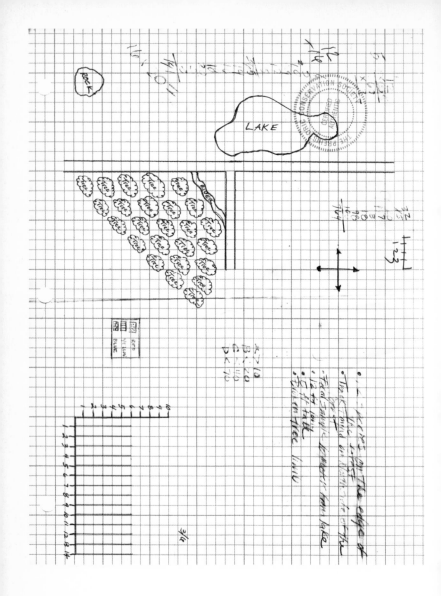

FICTIONAL MAPS

← THE PREHISTORIC CONSERVATION SOCIETY

GINA CUMBERLAND

Gina made up a story to explain her map: It was found in the lining of a binocular case abandoned on the Kansas prairie by Sir Alfred Griffen, a researcher of hybrid animals and associated breeding techniques. The text on the map references twelve different species found on the edge of the forest, some animal tracks, a fecal sample taken ten meters from the lake, and a curious broken tree limb.

↓ EMPATHEIA

SHANE WATT

Empatheia is a place Shane developed by mashing up major world cities, including Washington, D.C., London, Los Angeles, Tehran, Kabul, and Beijing among others. His vision of the military-industrial city of the near future includes, amongst other things, a Wal-Mart, neighboring oil and ethanol fields, a missile test range near the center of town, and various green spaces owned by large corporations such as Monsanto and McDonald's.

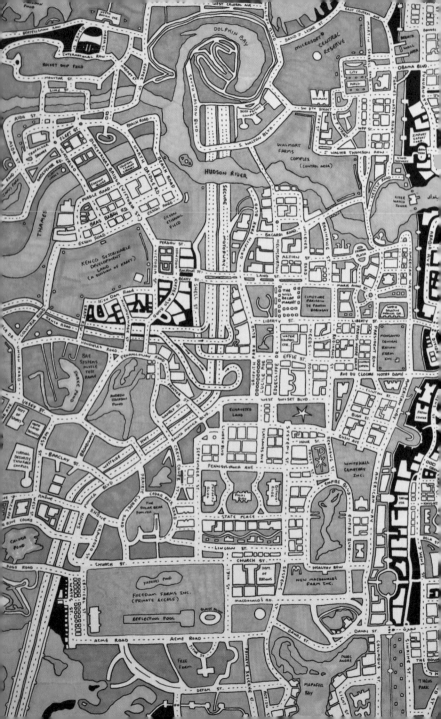

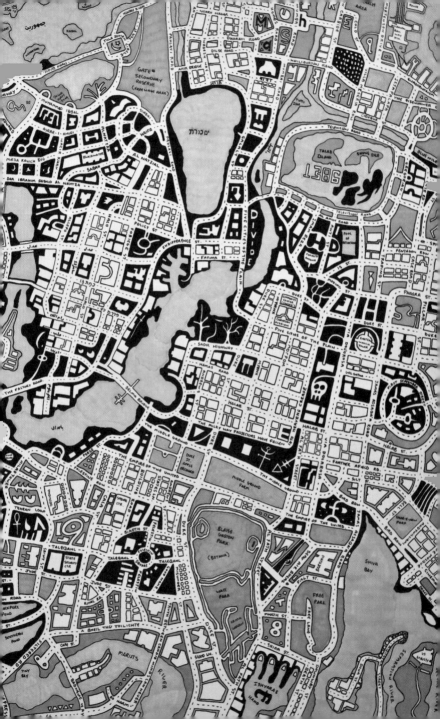

THE NEW → ↓
PANGAEA

DEAN VALADEZ

Dean created this map of a metaphorical Pangaea, the theorized supercontinent that existed before the continents separated. His vision reflects the idea that our understanding of traditional boundaries and borders is becoming blurred by humanity's increasing reliance on technology to navigate and comprehend the world around us.

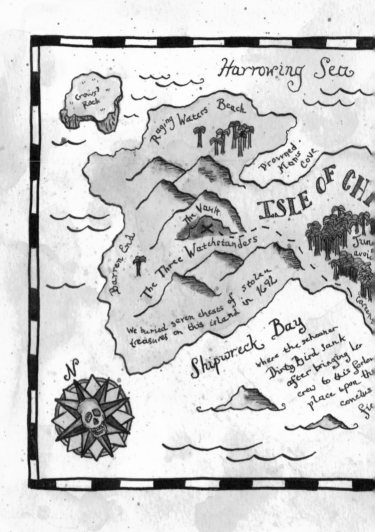

Harrowing Sea

"Crows' Rock"

Raging Waters Beach

Drowned Man's Cove

ISLE OF CHI...

The Vault

The Three Watchstanders

Barren End

Jun... avoi...

...taint...

We buried seven chests of stolen treasures on this island in 1692

Shipwreck Bay

where the schooner Dirty Bird sank after bringing her crew to this forlorn place upon the conclus... Sie...

N

ISLE OF CHANCE

ALISON MURRAY
WHITTINGTON

Alison's map of the Isle of Chance
depicts a treasure labeled "The
Vault," as well as a number of difficult
obstacles on the island such as
Shipwreck Bay, Jungle of Ghosts, and
Ambush Point, each with its own stern
warning to stay away.

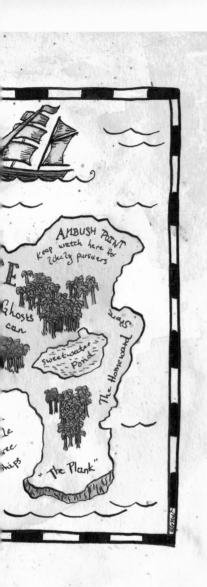

AMBUSH POINT
Keep watch here for
likely pursuers

Ghosts
can

Sweetwater
Pond

The Homeward

le
ree
hips

"The Plank"

QUASTOLIA

JAMIE MCQUINN

Jamie originally created Quastolia as a country for ants. The drawings were initially based on his backyard and later on the area surrounding Waterford, Michigan. When he was in the ninth grade, his teacher allowed him to do a report on his imaginary country for a class project. He completed a nineteen-page paper outlining all of the details including Quastolia's electoral process, military structure, and major religions. His teacher was impressed by the result, writing:

> What can I say! After sixteen years of teaching, this is the first time I have ever read anything so creative and different. You gave it considerable thought. Would you like to explain this to class?

Jamie responded by writing, "No way!" deciding it might not be a good idea to stand in front of his classmates and explain his country for ants. Today, however, Jamie documents the project on the Internet. The map shown here refers to the landmass as PUKQ, or the Protected United Kingdom of Quastolia. Jamie admits that the acronym was probably the result of his teenage sense of humor.

Utipian Sea

SYUKESH

KOROBAN EMPIRE

Metrigan

METRIGAN

Prycider Isl. (UVR)

LARANTAR

MAAULI

NURNU

Suarus
LARANO

CALUM

Mill Pond

WAIKMAN

Clarkston

ALTANA

Pharandon
Na-Con

Aslen

Rowingone

WAIKMAN

MISSALEN

Missalia

WEST AROUWE

EAST AROUWE

POWLENT

Rhatler

Tucalan

Squire

Dinzim

PUKQ

BEFORE TRANS-ECILIAN
WAR OF 121,538

☐ Kerd
☐ Duchy
☐ Royal Territory

South
Veltevic
Ocean

Frontier

LHANDLEF

BONEY

BOROUGH

DASH SHAW

This map illustrates various locations in Dash's comic *Body World*. At the beginning of each new scene, Dash refers to the map so readers can get a sense of individual characters' whereabouts. The design of Boney Borough is loosely based on Walt Disney's original plans for his utopian community, Epcot, an abandoned project that later became the famous theme park.

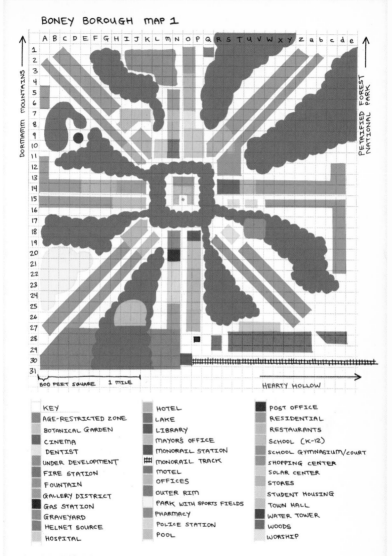

BONEY BOROUGH MAP 1

DORMAMM MOUNTAINS

PETRIFIED FOREST NATIONAL PARK

500 FEET SQUARE 1 MILE

HEARTY HOLLOW

KEY
AGE-RESTRICTED ZONE
BOTANICAL GARDEN
CINEMA
DENTIST
UNDER DEVELOPMENT
FIRE STATION
FOUNTAIN
GALLERY DISTRICT
GAS STATION
GRAVEYARD
HELNET SOURCE
HOSPITAL

HOTEL
LAKE
LIBRARY
MAYOR'S OFFICE
MONORAIL STATION
MONORAIL TRACK
MOTEL
OFFICES
OUTER RIM
PARK WITH SPORTS FIELDS
PHARMACY
POLICE STATION
POOL

POST OFFICE
RESIDENTIAL
RESTAURANTS
SCHOOL (K-12)
SCHOOL GYMNASIUM/COURT
SHOPPING CENTER
SOLAR CENTER
STORES
STUDENT HOUSING
TOWN HALL
WATER TOWER
WOODS
WORSHIP

ALL BUILDING ENTRANCES FACE THE WOODED AREAS, WITH THEIR
BACK DOORS / GARAGES FACING STREETS.
RESIDENTIAL HOUSING CONSTRUCTED WITH LOCAL LUMBER.

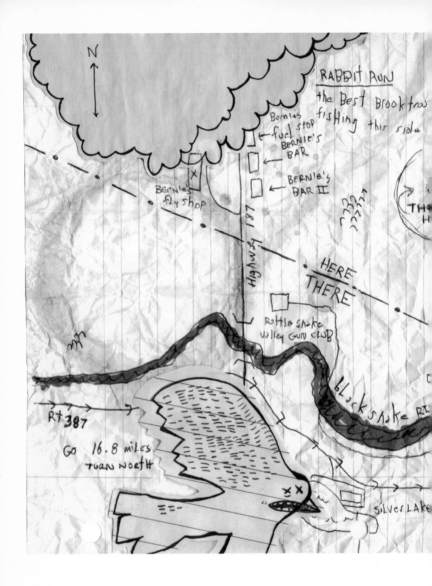

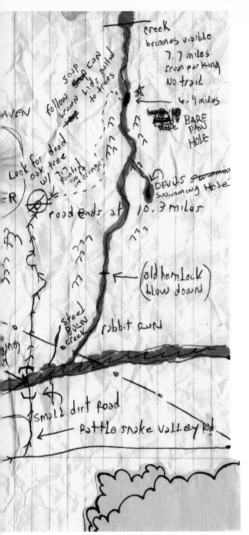

creek
becomes visible
7.7 miles
from parking
No trail

6.9 miles
BARE
PAW
HOLE

soip
can
follow brown kids pulled to trees

AVEN

Look for dead oak tree w/ tree

DEVILS swimming Hole
Swimming Hole

road ends at 10.3 miles

(old hemlock)
(blow down)

Steel Burn creek

rabbit Run

small dirt road

Rattle snake valley Rd.

RABBIT RUN

GARRICK DORSETT

Garrick created this detailed map to Rabbit Run, which features "the best brook trout fishing this side of heaven." He included the following note to Ernest Hemingway, wishing they could have fished together:

After some careful consideration I am finally ready to give up my directions to the elusive Bare Paw Hole, located on Rabbit Run. I know what you're thinking, but no need to worry, I am not dying. I just feel that it is time to share a little slice of brook trout heaven! I hope this letter finds you well. I have enclosed a photo from my last adventure to Rabbit Run as well as my famous fly deemed "the Hustler" by my friend Hap McKinney. Always remember what Norman said: "All good things—trout as well as eternal life—come by grace, and grace comes by art, and art does not come easy." Until we meet again, tight lines.

CONTOOCOOK

GRETCHEN MAYER

Gretchen created these maps in her journal during a road trip from Boston to Montreal. As she passed through New Hampshire, she became inspired by a town named Contoocook and drew two imaginary locations where, apparently, the inhabitants are clothespins.

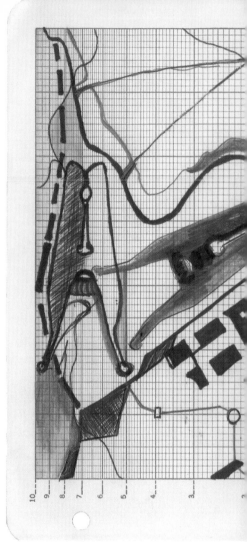

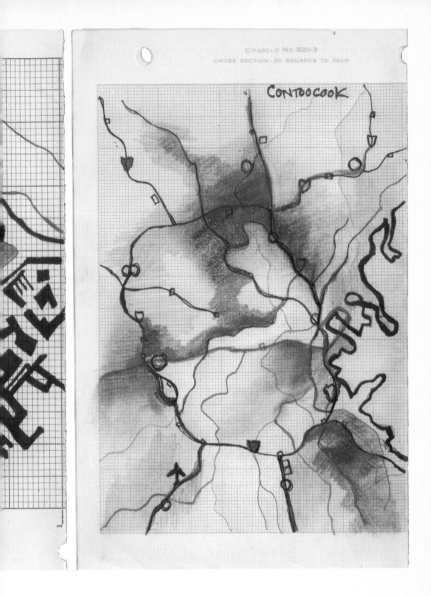

CONTOOCOOK

ARTFUL MAPS

BACHELORETTE PARTY

SAMPO SKIPIO

Sampo was assigned to draw this map for the bachelorette party of his wife's friend. The map shows important places of her youth that the bride-to-be had to recognize in order to follow the route. Her friends would be waiting in each spot to assign her various tasks. Some of the cryptic place names on the map include *Kontioiden valtakunta*, "the land of the bears," *halloweenin syntysija*, "where Halloween was born," *sagittariuksen mutkaopisto*, "the curved school of Sagittarius," and *jäämerelle*, "to the Arctic Ocean."

ESPOO, FINLAND

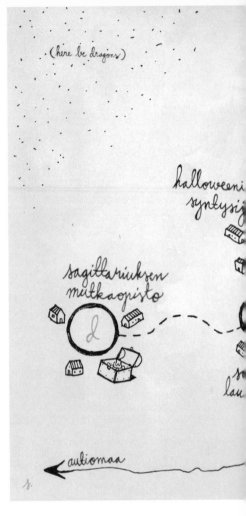

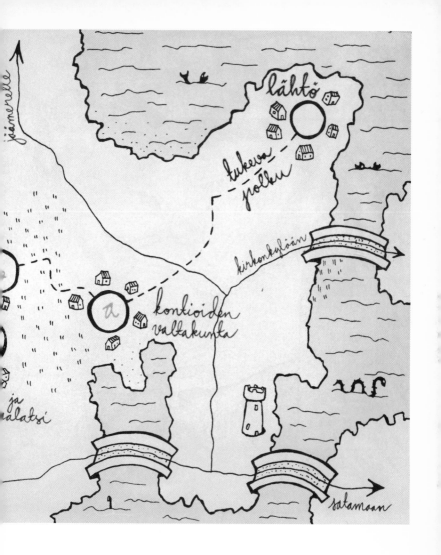

ARTFUL MAPS

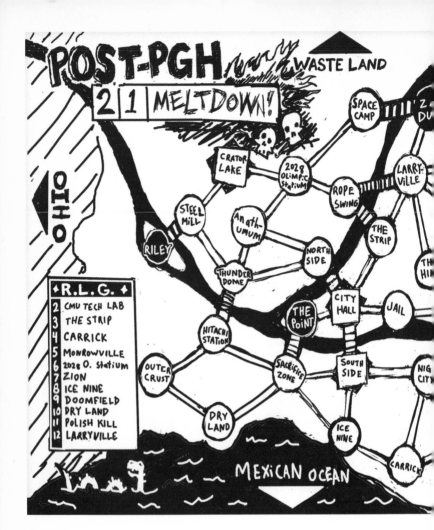

MELTDOWN

DANIEL MCCLOSKEY AND SHAKES

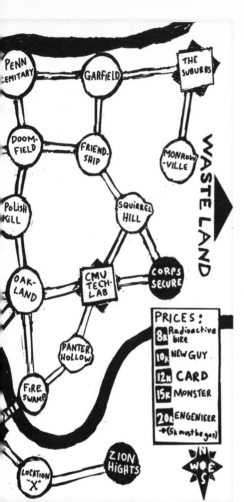

This map is part of a post-apocalyptic board game set in Pittsburgh. Created as a collaboration between Daniel McCloskey of the Cyberpunk Apocalypse writer's collective, and Shakes, author of the game zine *Olly Olly Oxen Free*, *Meltdown* is a *Risk*-style strategy game set in a future in which only Pittsburgh is left. Different groups such as mutants, hipsters, robots, and policemen battle each other for resources while trying to avoid plagues, floods, monsters, and nuclear meltdowns.

PITTSBURGH, PENNSYLVANIA

NAMSAN → ↓

MAYA HAN WEIMER

These images are taken from a video series that features Maya drawing maps of her neighborhood. South Korea can be disorienting for visitors because most of its streets are unnamed, but the government is beginning to implement a re-addressing program across Seoul. Maya's project tries to demonstrate how our ever expanding comprehension of a place, and our connection to it, influences both our individual and collective identity.

SEOUL, SOUTH KOREA

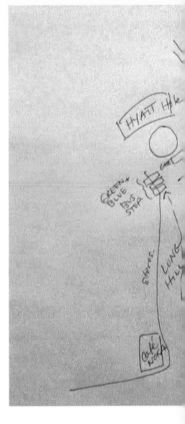

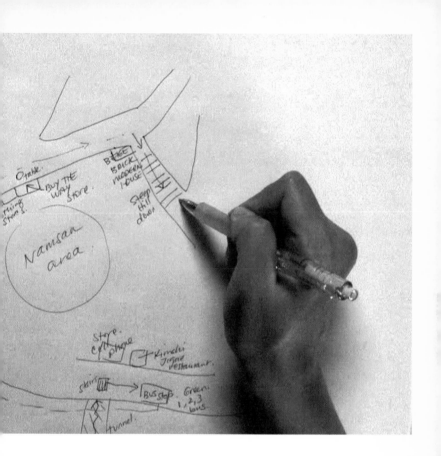

ARTFUL MAPS

CHILDHOOD FORT

KELLY THORN

Kelly created this detailed map of the woods surrounding her grandmother's cabin in New Jersey. The map includes various features around a fort she built as a child, including a neighboring fort made by Annie, her childhood nemesis.

SYLVAN LAKE, NEW JERSEY

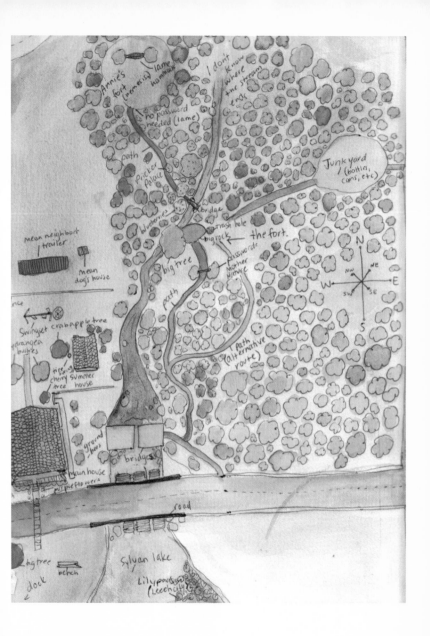

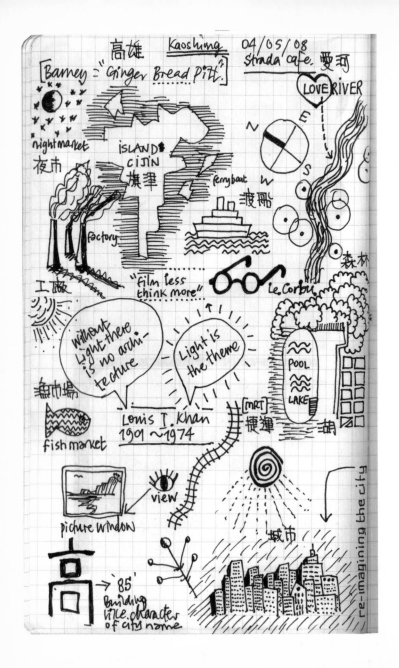

高雄　Kaoshing　04/05/08
strada cafe. 愛河

[Barney = "Ginger Bread Pitt."]

LOVE RIVER

night market
夜市

ISLAND
CIJIN
旗津

ferry boat
渡船

factory

N E S W

森林

工廠

"film less think more"

Le Corbu

魚市場

without light there is no architecture

Light is the theme

POOL

LAKE

[MRT]
捷運

fish market

Louis I. Khan
1901 ~ 1974

湖

view

picture window

城市

高 → '85'
Building
like. character
of city name

re-imagining the city

← SHARED

NOTEPAD

SHANE WALTER

Shane made this drawing of various places in and around Kaohsiung City in southern Taiwan while sitting at Cafe Strada on Jhongjeng Road. The cafe fosters a creative environment by providing communal sketchbooks and journals for customers to write and draw in. Features found on the map include the "85 Building" known as the Tuntex Sky Tower, one of the tallest buildings in the world, the MRT (Taiwan's mass-transit system), and the local *cianjhen* (fishmarket).

KAOHSIUNG CITY, TAIWAN

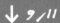

↓ 9/11

JOHN HUTCHISON

John drew this map to recount his journey from Manhattan to Brooklyn on September 11, 2001. The text describes the various points indicated in Manhattan and the thoughts that went through John's head while he was watching the towers burn.

NEW YORK CITY, NEW YORK

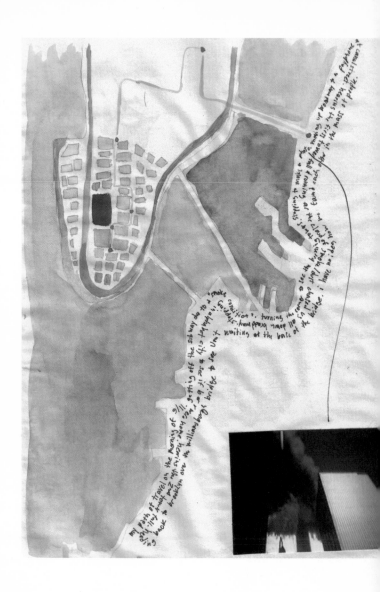

as i stood there watching the towers burn with my mouth wide open it didn't even occur to me to take a photo. i saw a woman rush out of a corner store with a disposable camera in her hands. she ripped open the package and started snapping away. the only camera i had on me was the eye module digital camera attached to my handspring visor. it was probably a 1.0 mega-pixel camera. i took a photo and realized i was watching people die. all i could do at that point was cry. i suppose that if i was truly a photographer i would have made more images but at the time it just didn't seem like the appropriate response. of course i didn't rush toward the burning buildings to help either. the scale of it all was too much for me to comprehend at that moment. that somehow i could effect events in some way. does that make me a bad person?

A VARIETY OF ↓ HOUSES: FROM THE SUBURBS TO THE SOUTH POLE

BETH HULL

NEW YORK CITY, NEW YORK

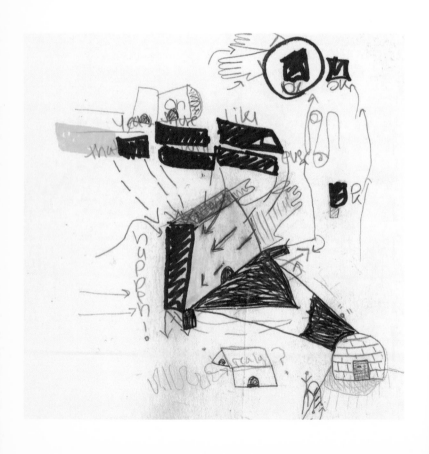

UNTITLED MAP ↑

BETH HULL

Beth draws maps and diagrams in her journals as a way to organize her ideas and experiences. She made these two maps at different times in her life. The first map represents various travels she made and cold temperatures she encountered along the way. The reference to the South Pole relates to dreams she was having while being surrounded by cold. The second map was created when Beth returned home. The triangular shape is a reference to the crawl space she used as a bedroom, and the floating objects are symbols of dreams she was having at the time.

SMALL CRAWL SPACE IN ARKANSAS

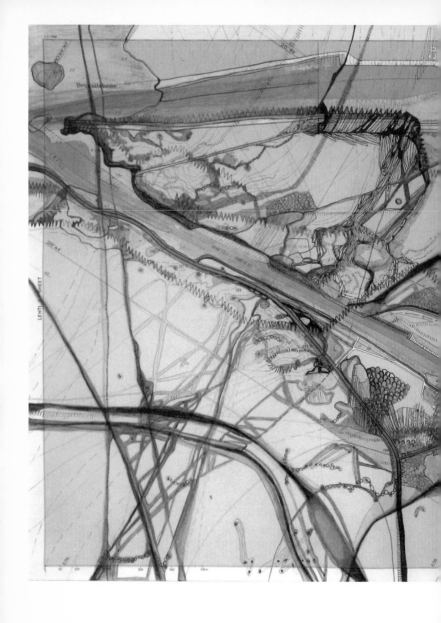

MODIFIED MAP

ORVOKKI HALME

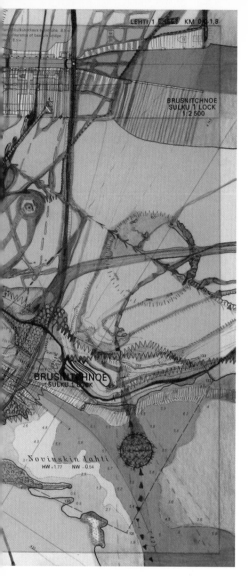

Orvokki made this image by drawing over a found map of the Saimaa Canal in Finland. Her exploratory lines reinterpret the actual geography of the landscape, creating a personal, abstracted narrative on top of this shared space. Orvokki is of Finnish descent and was the first in her family to be born in America. As an adult, she moved to Helsinki, where she found a large navigational book of the Saimaa Canal at a flea market. As a way to explore her family history, she created this drawing on top of one of the pages in the book.

SAIMAA CANAL, FINLAND

DIVING

JEFF WOODBURY

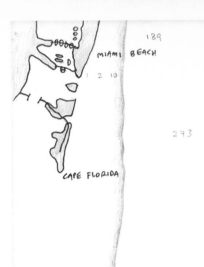

In May of 1996, Jeff spent a week with his father scuba diving near Bimini, the Bahamas. At night, he would study charts and draw maps of the places they dived. They sailed from Miami one night and woke up off the coast of Bimini the next morning.
In this drawing, the book's binding suggests a break in conscious understanding. Similar to traveling on a long plane flight, we are aware of our departure when we leave and aware again when we arrive, but the journey between the two locations is often beyond the grasp of our comprehension.

BIMINI, THE BAHAMAS

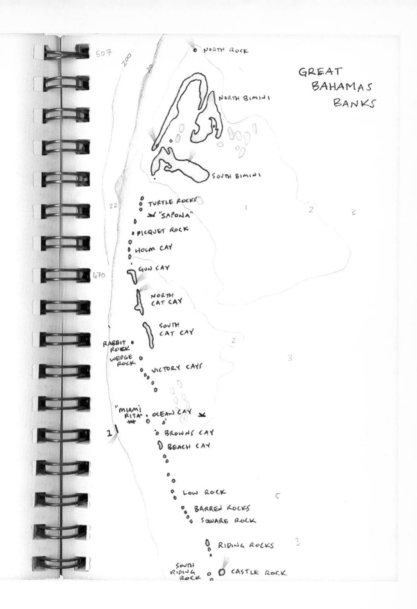

North Rock

GREAT
BAHAMAS
BANKS

507 200

20

NORTH BIMINI

SOUTH BIMINI

22 TURTLE ROCKS
 "SAPONA"
 PICQUET ROCK
 HOLM CAY
 GUN CAY
670
 NORTH
 CAT CAY

 SOUTH
 CAT CAY
RABBIT
ROCK
WEDGE
ROCK VICTORY CAYS

"MIAMI
RITA" OCEAN CAY
1
 BROWNS CAY
 BEACH CAY

 LOW ROCK 5
 BARREN ROCKS
 SQUARE ROCK

 RIDING ROCKS 3
SOUTH
RIDING
ROCK CASTLE ROCK

1 2 3

2

3

TIMELINE STUDY

SAGE DAWSON

This is a map of various parks Sage visited throughout her life. The map clearly puts place at the forefront of organizing our thoughts. Her work proposes that memories reside not just in our minds—perhaps they also occupy the locations where an event took place. When you drive through an area you haven't visited in years, the environment can become a trigger for memories and emotions.

VARIOUS LOCATIONS

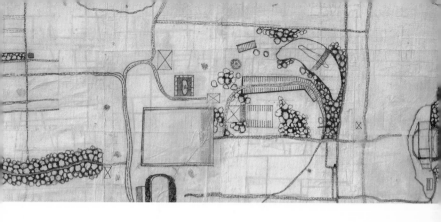

ARTFUL MAPS

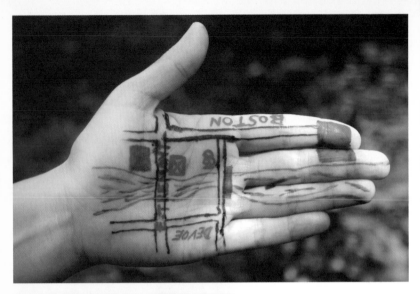

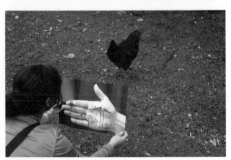

ARTFUL MAPS

← META MAPA
↓ YUMI ROTH

In her ongoing project *Meta Mapa*, Yumi invites local residents to draw maps on their hands that lead to interesting places in their neighborhoods. She photographs the maps and then prints them to create actual maps that she and others then use to navigate the city. Yumi created the pieces presented here in 2008 as part of an exhibition called Surprisingly Natural, at the Bronx River Art Center. She asked residents of the neighborhood around the center to draw maps on their hands to hidden or little-known green spaces. One of the maps led her to a place where a husband and wife were keeping chickens and tending to a small urban garden, in what Yumi described as a median strip.

NEW YORK CITY, NEW YORK

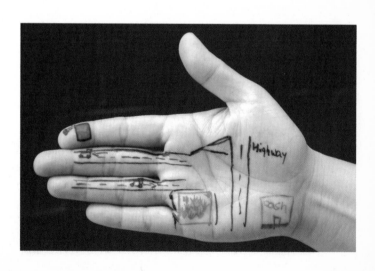

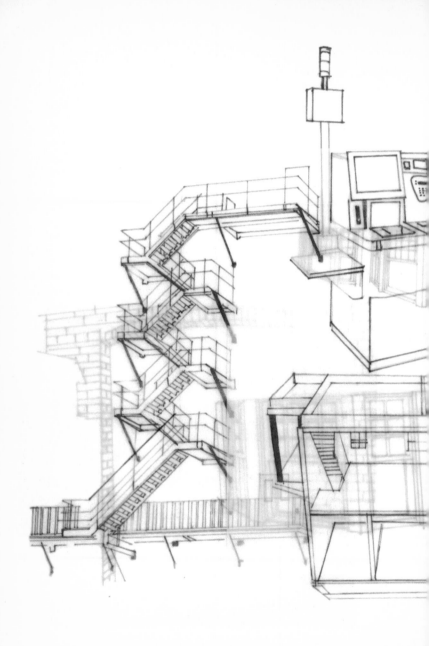

CHECKOUT

BECKY BLOSSER

Becky's map provides a glimpse of her daily life. By placing various objects next to one another, she forms a diagram of the connections between architectural elements she encounters on a regular basis. A fragmented view of her reality, the map becomes a fictional journey from Becky's home to the grocery store, as seen through an inventory of the built environment.

VARIOUS LOCATIONS

ENOSHIMA, ONE YEAR LATER

RACHEL FOSTER

Enoshima is a small island outside of Tokyo. Rachel visited the island regularly while she was in Japan on a teaching stint and fell in love with the place. After returning home to the United States, she occasionally drew maps to help her remember it. This map was drawn about a year after her last visit. She writes:

> Every day for one year I rode by bicycle to Enoshima Island, which is the most relaxing and interesting place I've ever been to. From here you can watch the sun set over Mt. Fuji as the city lights glow on the horizon.

TOKYO, JAPAN

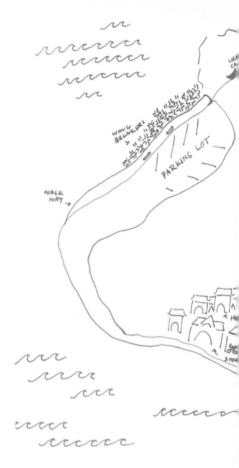

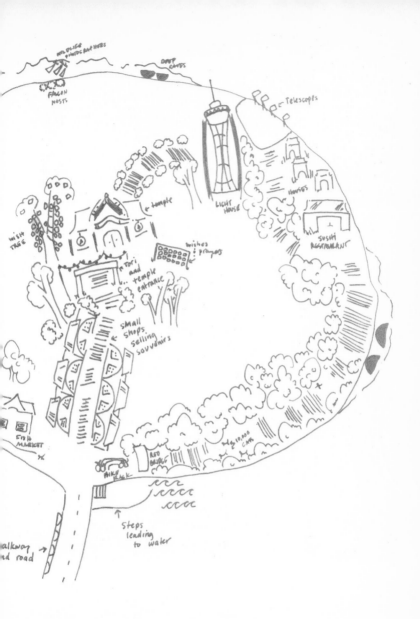

WILDLIFE
POND/BATHERS

FALCON
NESTS

DRIP CAVES

Telescopes

temple

LIGHT HOUSE

HOUSES

wishes & prayers

WISH TREE

Tori and temple entrance

SUSHI RESTAURANT

small shops selling souvenirs

FISH MARKET

RED BRIDGE

BIRD PARK

THE 10,000 CAVES

walkway and road

Steps leading to water

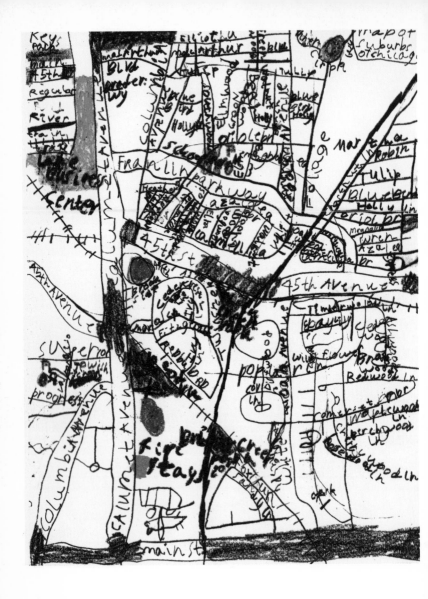

← SUBURBS

MICHAEL AND ELI NIRENBERG

This map was drawn by Michael's eight-year-old son Eli. Eli spends hours studying maps and creating drawings like this one. It is actually quite accurate, and you could probably use it to help you find your way through the suburbs of Chicago if your GPS started to fail you.

CHICAGO, ILLINOIS

↓ CHINATOWN

SUE MARK AND BRUCE DOUGLAS WITH HARRY LIM

Octogenarian and long-time resident of Oakland's Chinatown, Harry Lim, created this map, which depicts many of the changes that have taken place over the years in one of America's most active Chinatown communities. The map was collected by Sue Mark and Bruce Douglas (a creative team known as marksearch) as part of 10,000 Steps, a unique multiyear collaboration among artists, the municipality, citizen groups, and nonprofit advocacy organizations. The project aims to beautify and draw attention to four historic parks in downtown Oakland through on-site stewardship and a self-guided walking tour that incorporates Oaklander's stories and experiences of Lincoln, Madison, Jefferson, and Lafayette Square parks.

OAKLAND, CALIFORNIA

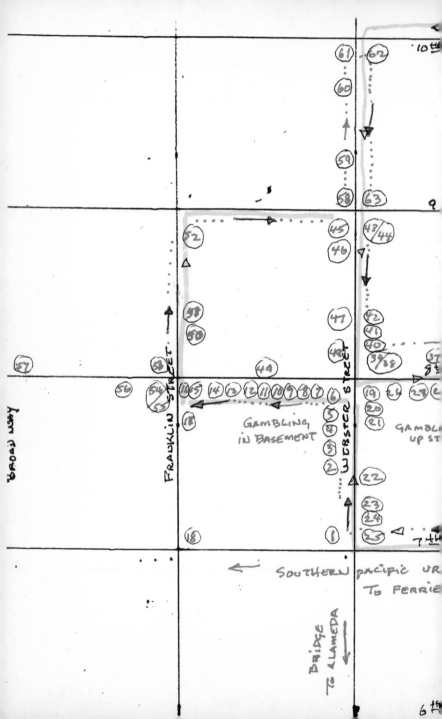

START LINCOLN SQUARE

LINCOLN SCHOOL

ᴱᴱᵀ (64)

74

FIRE
STATION

(65) (66)
(67)

ALICE STREET

(69)
(71)

(70)

JACKSON STREET

ᴿᴱᴱᵀ ³⁵/₃₄

(3)(31)(92)(3)

HARRISON STREET

START

LIVED
HERE *

(73)

ᴱᵀ
ᴱᴱᵀ

(72)

LINE'

1 ST PARK
WAS
CHAN BOK HING
ESTATE

POSEY
TUBE

ᴱᴱᵀ

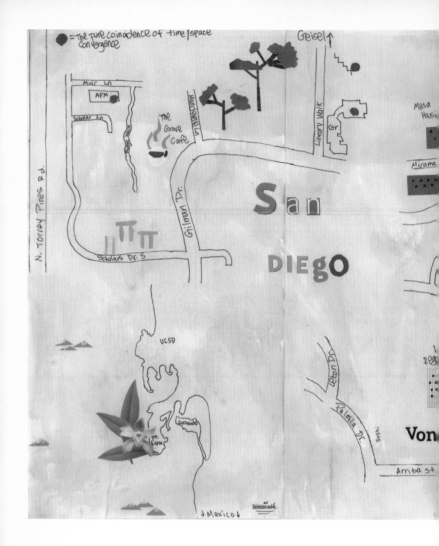

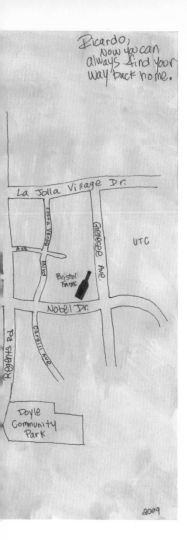

Ricardo,
Now you can
always find your
way back home.

La Jolla Village Dr.

CASA VEGA

Genesee Ave.

AVE

BLVD

UTC

Bristol Farms

Nobel Dr.

Regents Rd

CARBELL RD

Doyle
Community
Park

2009

← COLLAGE MAP

RICARDO ALEJANDRO FAGOAGA HERNANDEZ

Ricardo's friend Pauline Chavez made this map of San Diego for him. It points to various landmarks in the city, including a favorite coffee shop and Vons, a local grocery store chain. Along with the inscription, "Ricardo, now you can always find your way back home," it also includes a point marked "the pure coincidence of time/space convergence," referring to the place where Ricardo asked Pauline out on a date for the first time. It was a coincidence because the two just happened to be walking past one another on the street.

SAN DIEGO, CALIFORNIA

↓ WANDERING

MICHAEL HILL

Michael drew this map of Bath for a London newspaper to accompany a travel article on the city. The newspaper eventually decided to use a more formal map for publication, but this drawing creates a convincing illusion of someone wandering the streets of Bath while jotting down the different sites they saw.

BATH, ENGLAND

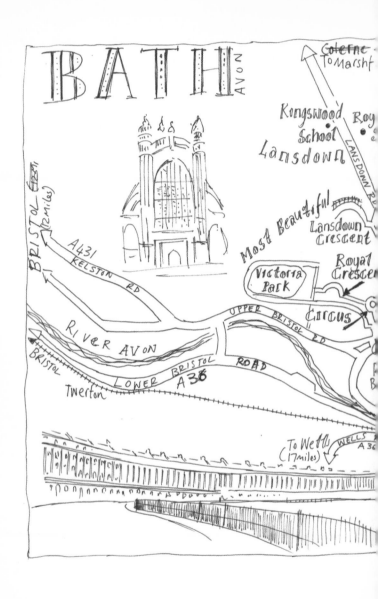

BATH AVON

Colerne
To Marshf

Kingswood
School
Lansdown

Roy

LANSDOWN RD

BRISTOL (12 miles)

A431
KELSTON RD

Most Beautiful

Lansdown
Crescent

Royal
Crescen

Victoria
Park

Circus

UPPER BRISTOL RD

RIVER AVON

BRISTOL

LOWER BRISTOL ROAD
A36

Twerton

To Wells
(17 miles)

WELLS
A 36

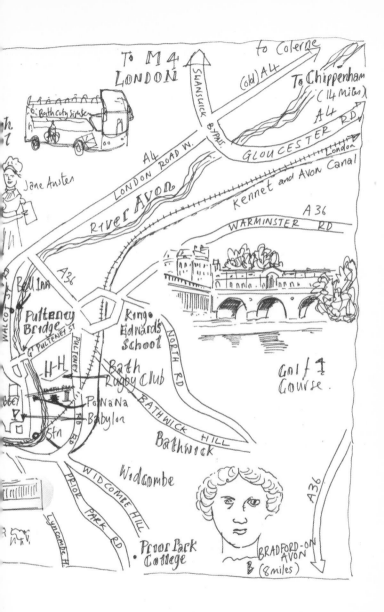

To M4
LONDON

to Colerne

(old) A4

To Chippenham
(14 miles)

A4

SWAINSWICK BYPASS

GLOUCESTER RD

London

Bath City Sights

Jane Austen

A4

LONDON ROAD W.

River Avon

Kennet and Avon Canal

WARMINSTER RD

A 36

Bell Inn

A 36

Pulteney
Bridge

G. PULTENEY ST

PULTENEY ST

King
Edward's
School

NORTH RD

Golf $\frac{1}{2}$
Course.

MALCO ST

H·H

Bath
Rugby Club

BATHWICK HILL

Stn

PoNaNa
Babylon

Bathwick

Widcombe

WIDCOMBE HILL

PRIOR PARK RD

Lyncombe H

Prior Park
College

BRADFORD-ON-
AVON

A 36

B (8 miles)

THE RIDGE
ACCORDING
TO DAN

DAN SCHMIDT

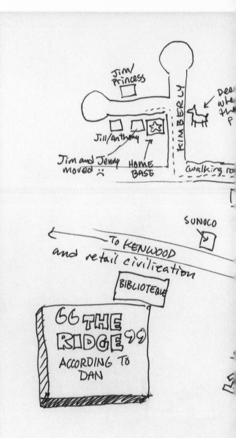

Dan was sitting in a coffee shop called the Pleasant Perk (noted as "the Perk" on the map) when he was approached by a graduate student who asked him to draw a map of his neighborhood, Pleasant Ridge, from his perspective, for an urban planning project. Dan's drawing includes the house that he almost bought, his walking route to play Trivia with friends, and his favorite farmers' market—it even references the deer that keep visiting the neighborhood.
CINCINNATI, OHIO

THE DEPOT

biggs
(thank you for remodeling)

RIDGE

HOUSE I ALMOST BOUGHT

(trivia)

a church I do not go to

NATIVITY

WOODFORD

But I like the farmers market

ALOW
NG HOUSE
KE

BK

EVERY BODY'S RECORDS

UDF
↑ BEER GAS

LA ROSA'S

NTGOMERY

MOLLY MALONE'S

"THE PERK"

caffiene is my friend

A
DAY

ACE!

comic book store I keep meaning to go to

TOYS

to NORWOOD →
my Dad grew up there, Clara lives there

BOSTON

BOSTON COMMON

MASON
WEST
TREMONT
TEMPLE
WASHINGTON
PARK
SCHOOL
BOWDOIN
SOMERSET
COURT

BEACON
CHESTNUT
WALNUT
MT. VER.
JOY

OLD STATE HOUSE.

CLUB OF ODD VOLUMES

PIER GUSTAFSON

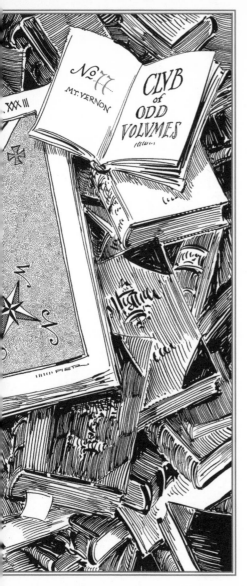

Pier, a professional illustrator who creates maps for significant events in people's lives, drew this map of Boston for use in a wedding invitation. It directs guests from the ceremony to a reception at a men's club called the Club of Odd Volumes. The two grooms were to display a selection of books from their personal libraries on a table near the club's entrance, so that guests could learn more about the grooms' respective personalities and interests. This and the club's name inspired Pier to draw a pile of books as the background for the map.

BOSTON, MASSACHUSETTS

NINE POINTS

PIER GUSTAFSON

Pier's map directs people from
anywhere in the solar system to
his studio in Somerville. The map
zooms in a little more with each step,
progressing from the solar system
(at nine o'clock) to Massachusetts
(12 o'clock) through various roads
until you find yourself standing at
his desk in his studio (5 o'clock).
On the desk, you see the map itself
in process, and the last image of a
detail of the map leads back to the
beginning.

SOMERVILLE, MASSACHUSETTS

ARTFUL MAPS

PITFALL

VICENTE MONTELONGO

Vicente makes GPS drawings of pixelated Atari characters by searching out areas of the city that are laid out in a grid and then tracing a route that creates a specific design. Using this sketched map, he rides his bike with a GPS tracker installed, following the route exactly. The result is a perfectly tracked GPS trail that he uploads on the Internet and imports into various mapping applications. The drawing becomes a record of the experience of moving through a city. His journey is transformed into data—stating not only the route traveled but also the speed and elevation of the journey—that anyone can view and interpret.

SAN FRANCISCO, CALIFORNIA

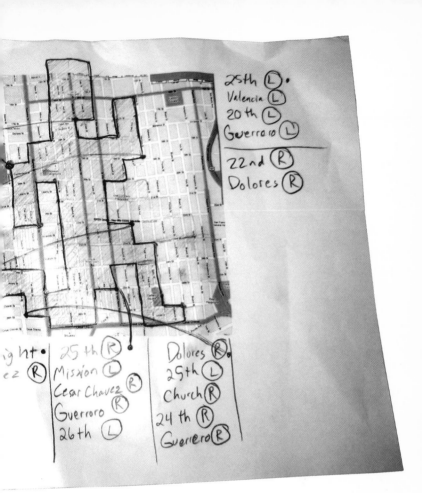

25th Ⓛ •
Valencia Ⓛ
20th Ⓛ
Guerraro Ⓛ

22nd Ⓡ
Dolores Ⓡ

ight •
ez Ⓡ

25th Ⓡ
Mission Ⓛ
Cesar Chavez Ⓡ
Guerroro Ⓡ
26th Ⓛ

Dolores Ⓡ •
25th Ⓛ
Church Ⓡ
24th Ⓡ
Guerrero Ⓡ

MAPS OF UNUSUAL PLACES

EMOTIONAL MAP

KAREY KESSLER

Karey uses maps to create contemplative diagrams of emotions and thoughts. She writes:

> There is no map for navigating your own emotional and mental landscape. I like the idea of trying to map out what cannot be mapped out. As much as I might want to, I cannot truly map a fleeting memory, a moment of dissolving time, or the spaces and gaps between spaces and gaps.

Karey drew this map on a piece of paper she had saved for years. While going through some old high school notes, she rediscovered the graphing paper as a medium for documenting her stream of consciousness. In this map, even the paper itself becomes a record of a moment in time. The yellowing paper—used at one time for a math class—is a memory on which new memories, feelings, and emotions are diagrammed.

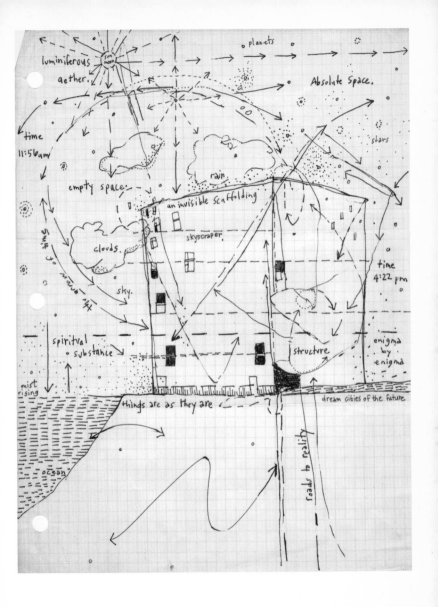

luminiferous aether.

planets

Absolute Space.

time 11:56 am

stars

empty space.

rain

an invisible scaffolding

skyscraper

clouds.

time 4:22 pm

sky.

the edge of sight

spiritual substance

structure

enigma by enigma

mist rising

things are as they are

dream cities of the future

ocean

roads to reality

THE INTERNET MAPPING PROJECT

KEVIN KELLY

Kevin's *Internet Mapping Project*
documents how individuals visualize
their relationship to the Internet.
The Web is a unique subject for a
map, for although there are specific
destinations, visited every day by
people all over the world, there is
no clear geography to its terrain.
Kevin's project reveals that everyone
surfing the net creates his or her own
sense of order from the vast field of
information. Both of these maps put
Google at the forefront. In the first
map, Google becomes the river that
flows through every terminus on the
map. Along the shores of the Google
river, we find common destinations,
such as the vast plain of YouTube that
must be crossed to reach other sites.
The second map seems to imply that
simply searching and hitting the "Go"
button will reveal the correct location.
Perhaps this is not always the best
solution, as the figure appears to
be suffering from a bad case of
information overload.

THE INTERNET MAPPING PROJECT

Please draw a map of the internet, as you see it. Indicate your "home."

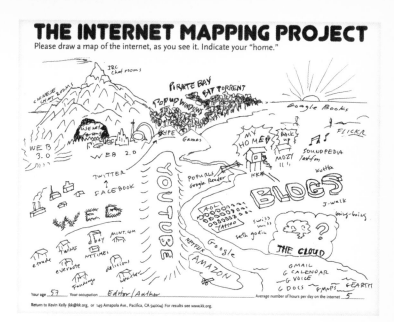

Your age _57_ Your occupation _Editor/Author_ Average number of hours per day on the internet _5_

Return to Kevin Kelly (kk@kk.org, or 149 Amapola Ave., Pacifica, CA 94004) For results see www.kk.org.

THE INTERNET MAPPING PROJECT

Please draw a map of the internet, as you see it. Indicate your "home."

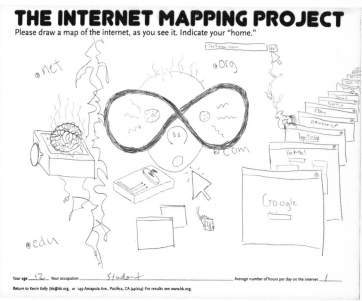

Your age _12_ Your occupation _Student_ Average number of hours per day on the internet _1_

Return to Kevin Kelly (kk@kk.org, or 149 Amapola Ave., Pacifica, CA 94004) For results see www.kk.org.

Newest Freckles.
Appeared after the
summer of 2006.
More will be acquired
this summer, as I
expand my garden.

chicken Pox Scar
Spring, 1982

Scar from
Stitches. Injury
from a rogue grounder
during a softball game.
I was playing 2nd base.
Spring 1992-93.

#6: Close-up: Eyes & Nose: Front View: February 21, 2009

HISTORY OF ↑

THE FACE →

HARRIET HACKER

Harriet's maps of her face and
upper chest illustrate various facial
markings, such as lots of freckles, a
chicken pox scar from 1982, a beauty
mark she was born with in 1974, as
well as scars from thyroid surgery,
a softball injury, and mole removals.
Harriet created the maps because
she started to see her moles and
sun damage as beautiful—a personal
map on her body documenting her
life story.

→ August 27, 2007
Scar from thyroid surgery.
My whole thyroid was
removed. I don't scar easily,
but when I do, they stay
around for
awhile. This scar
has healed a little
already.

⊂⊃ ← Shunt scar

* The rest are freckles

#4: Close-up: Upper Chest: February 21, 2009

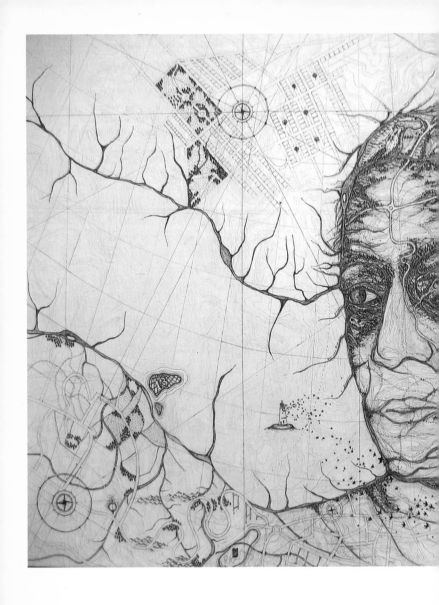

MAPS OF UNUSUAL PLACES

THE FUTURE IS UNWRITTEN

GOWRI SAVOOR

Gowri's self-portrait represents her idea of a human mapping system. She explores how our bodies, specifically our faces, reveal clues to our past, present, and future. She believes faces contain elements that chart our individual existence. Within our faces we find family history, experiences, fears, and even dreams.

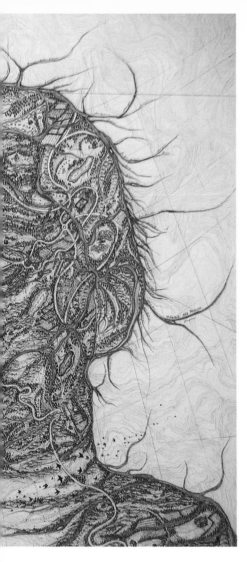

HUMIRA →
INJECTIONS ↓

MARILYN MURPHY

Marilyn creates maps on index cards to help her remember the sites of her Humira injections. She must inject the drug into her stomach or thighs to treat her juvenile rheumatoid arthritis. At the time she drew these maps, she was taking injections about every two weeks. In order to give the site of the injections time to heal, she maps and dates them. Pictured here are two maps: One shows a year of injections on her stomach from July 14, 2005 to July 6, 2006, and the other, injections on her thighs from March 5 to September 8, 2007.

TEMPE, ARIZONA

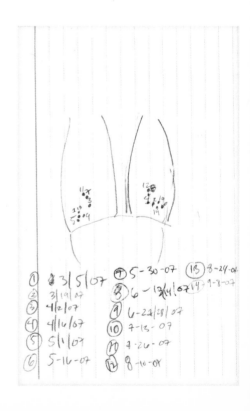

1) 7-14-05 10) 11-20-05
2) 7-28-05 11) 12-4-05
3) 8-12-05 12) 12-18-05
 13) 1-1-06 (12-30-05)
4) 8-27-05 14) 1-13-06 1-16-06
5) 9-11-05 15) 1-29-06
6) 9-25-05 16) 2-12-06 21) 4-26-06
7) 10-9-05 17) 2-26-06 22) 5-11-06
8) 10-23-05 18) 3-14-06 23) 5-25-06
9) 11-6-05 19) 3-28-06 24) 6-8-06
 20) 4-12-06 25) 6/22/06
 26) 7-6-06

MAP OF MY LOCKER

CAROLINE DOROTHY REX

Caroline drew this map of her locker
—one place she knew better than
anyone else—when she attended
seventh grade at J. T. Hutchinson
Middle School in Lubbock, Texas. Her
drawing depicts crumpled-up papers
and trash at the locker's bottom,
along with several magnets, a Jonas
Brothers poster, her book bag, jacket,
and a fish hanging from a hook at the
top, given to Caroline by a friend.
LUBBOCK, TEXAS

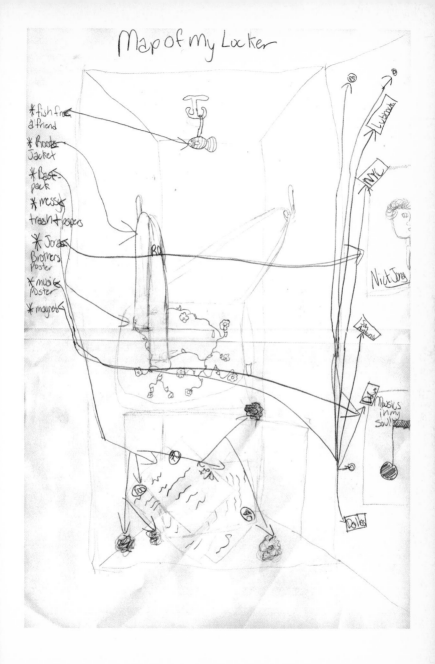

Map of my Locker

* fish from
 d'friend
* Roots
 Jacket
* Back-
 pack
* messy
 trash + papers
* Jonas
 Brothers
 Poster
* music
 Poster
* magnets

Lubbock

NYC

Nick Jonas

Dan
Musics
in my
soul

Dallas

TRAFFIC ISLAND

LUCAS IHLEN

This obsessive map documents an ordinary part of our daily lives. Lucas chronicled all the garbage he found on a median strip in Adelaide, Australia, in late 2006. The map includes, among other things, quite a bit of fast food trash, a ball of tin foil, a pink marker, a broken mobile phone battery, and "Hollywood colour smoking fountain fireworks." The map is also divided into regions, such as the "zone of embarrassment," a particularly shady spot, and a section with lots of ants.

ADELAIDE, AUSTRALIA

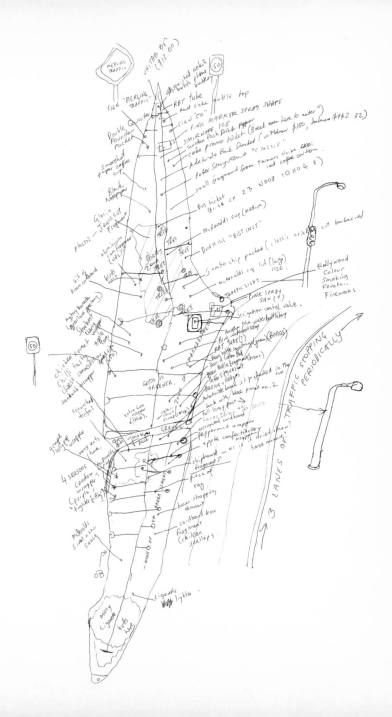

FRONT ROW, →

SOMETIMES

FURTHER

TONY GONZALEZ

A big live music fan, Tony created
this map to show his proximity to the
stage at the many concerts he has
attended.
VARIOUS LOCATIONS

↓ JIM MARCY'S

SUNSPOT AND

SUN FLARE

OBSERVATIONS

SHAUN O'DELL

Shaun's drawing is based on
observations of sunspots and sun
flares recorded by Jim Marcy, an
amateur astronomer. When Jim
showed Shaun his meticulous
recordings and drawings, Shaun
decided to pay homage to the sun
as the source of creativity on Earth
by redrawing one year of Jim's
observations in concentric rings.
SAN FRANCISCO, CALIFORNIA

"Front Row, Sometimes Further"

stage

The Dirtbombs

Dungen Wolf Eagles Black
 Parade of Death Keys
 Metal

 The Aisves of Os Mutantes
The Presidents Montreal
of the USA. Yo La Tengo
 Jens Lekman
Circulatory Tapes n Tapes
System

 Spoon
 Yo La Tengo

 Of Montreal The Starlight
 Mints

 The White Stripes

 Andrew Bird

 Wolf Parade

 The Futureheads

Yo La Tengo

 Weird Al Andrew Bird
 They Might Be Giants

Silver Jews

 Man Man

MAPS OF UNUSUAL PLACES

EXPLANATORY MAPS

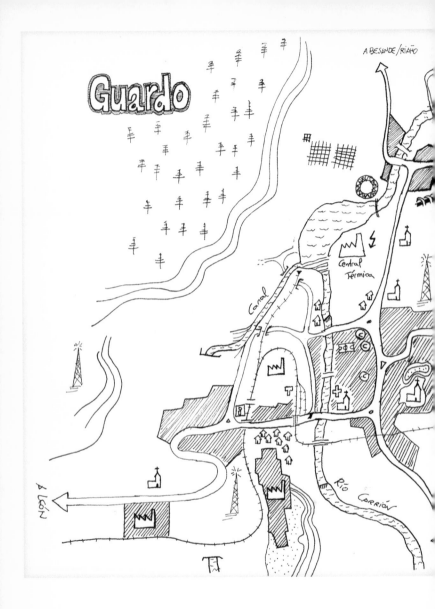

HOMETOWN

ALEJANDRO POLANCO MASA

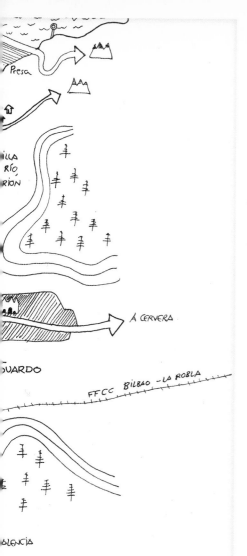

This map depicts Alejandro's hometown of Guardo, a small town in northern Spain. It emphasizes transportation infrastructure as well as energy resources and other industries in the area.

GUARDO, SPAIN

Presa

ILLA
RÍO
RIÓN

A CERVERA

ÚARDO

FFCC BILBAO - LA ROBLA

ÓLENCIA

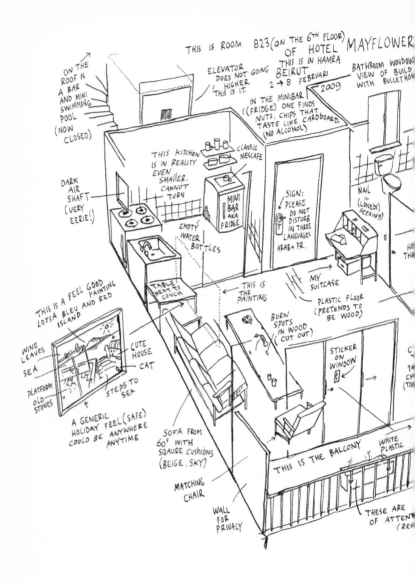

THIS IS ROOM 823 (ON THE 6TH FLOOR) OF HOTEL MAYFLOWER

THIS IS IN HAMRA BEIRUT

2 → 8 FEBRUARI 2009

ON THE ROOF IS A BAR AND MINI SWIMMING POOL (NOW CLOSED)

ELEVATOR DOES NOT GOING HIGHER THIS IS IT.

BATHROOM WINDOW VIEW OF BUILD WITH BULLET HO

IN THE MINIBAR ((FRIDGE) ONE FINDS NUTS, CHIPS THAT TASTE LIKE CARDBOARD. (NO ALCOHOL)

THIS KITCHEN IS IN REALITY EVEN SMALLER. CANNOT TURN

CLASSIC NESCAFE

MINI BAR AKA FRIDGE.

DARK AIR SHAFT (VERY EERIE!)

SIGN: PLEASE DO NOT DISTURB IN THREE LANGUAGES ARAB + FR.

NAIL (LONELY SEEKING)

EMPTY WATER BOTTLES

HE TH

MY SUITCASE

THIS IS THE PAINTING

PLASTIC FLOOR (PRETENDS TO BE WOOD)

TABLE NEXT TO COUCH

THIS IS A FEEL GOOD PAINTING LOTSA BLEU AND RED ISLAND

BURN SPOTS IN WOOD (CUT OUT)

STICKER ON WINDOW

WINE LEAVES

SEA

CUTE HOUSE

CAT

PLATFORM OLD STONES

STEPS TO SEA

A GENERIC HOLIDAY FEEL (SAFE) COULD BE ANYWHERE ANYTIME

SOFA FROM 60s WITH SQAURE CUSHIONS (BEIGE, SKY)

THIS IS THE BALLONY

WHITE PLASTIC

MATCHING CHAIR

WALL FOR PRIVACY

THESE ARE OF ATTENT (REA

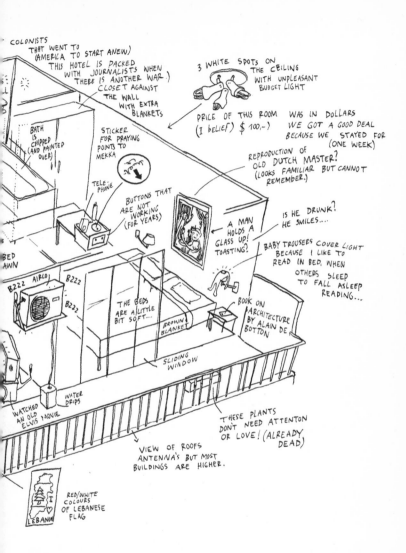

COLONISTS THAT WENT TO (AMERICA TO START ANEW) THIS HOTEL IS PACKED WITH JOURNALISTS WHEN THERE IS ANOTHER WAR.) CLOSET AGAINST THE WALL WITH EXTRA BLANKETS

3 WHITE SPOTS ON THE CEILING WITH UNPLEASANT BUDGET LIGHT

PRICE OF THIS ROOM WAS IN DOLLARS (I bELIEF) $ 100,-) WE GOT A GOOD DEAL BECAUSE WE STAYED FOR (ONE WEEK)

REPRODUCTION OF OLD DUTCH MASTER? (LOOKS FAMILIAR BUT CANNOT REMEMBER.)

BATH IS CHIPPED (AND PAINTED OVER)

STICKER FOR PRAYING POINTS TO MEKKA

TELEPHONE

BUTTONS THAT ARE NOT WORKING (FOR YEARS)

A MAN HOLDS A GLASS UP! TOASTING?

IS HE DRUNK? HE SMILES...

BABY TROUSERS COVER LIGHT BECAUSE I LIKE TO READ IN BED, WHEN OTHERS SLEEP TO FALL ASLEEP READING...

BED AWN

B222 AIRCO

B222

B222

THE BEDS ARE A LITTLE BIT SOFT....

BROWN BLANKET

BOOK ON ARCHITECTURE BY ALAIN DE BOTTON

SLIDING WINDOW

WATCHED AN OLD ELVIS MOVIE

WATER DRIPS

THESE PLANTS DON'T NEED ATTENTION OR LOVE! (ALREADY DEAD)

VIEW OF ROOFS ANTENNA'S BUT MOST BUILDINGS ARE HIGHER.

RED/WHITE COLOURS OF LEBANESE FLAG

LEBANON

MAYFLOWER

HOTEL

JAN ROTHUIZEN

This map shows a room at the
Mayflower Hotel in Beirut, which is
often filled with journalists when
there is a war. Jan stayed there for a
week in February 2009. On the map,
he obsessively documents every
aspect of the room, including an "I ♥
Lebanon" sticker on the window of the
sliding door, an eerie air shaft, and
burn spots on the coffee table, as well
as the baby clothes he placed on the
bedside lamp for reading at night and
the movie he watched on the room's
television.

BEIRUT, LEBANON

ANNE FRANK HOUSE, HET ACHTERHUIS (THE BEHIND HOUSE OR HIDING HOUSE)

JAN ROTHUIZEN

This documentary interior map by Jan records his recent visit to the Anne Frank House in Amsterdam. Jan drew a variety of details, contemplating the home's importance as both a historic site and popular tourist attraction. As he notes on the map, a local newspaper called the Anne Frank House "Amsterdam's strongest brand." The drawing records various other details, such as the greasy fingerprints from tourists touching the sliding cupboard, places where Anne's grandfather had removed wallpaper (thinking the house would be destroyed), and an exchange between Jan and the security personnel because he had accidentally left his bag in one of the rooms.

AMSTERDAM, THE NETHERLANDS

HERENGRACHT 263 MONDAY APRIL 6 2009
(HET ACHTERHUIS) ← THE BEHIND HOUSE (HIDING)

8:05 FLOORS STILL WET FROM CLEANING...

8:15 YOUNG MAN WITH LITTLE BLACK CURLS WALKS IN
 HIS NAME IS KADA HE INSPECTS THE CLEANING OF
 HIS OLDER MORROCAN COLLEAGUES

8:30 I READ THE DIARY OF ANNE FRANK IN ENGLISH WHILE
 I WAS LIVING IN AMERICA. IN THE BOOK SHE
 DESCRIBES THE SOUND OF A CHURCH NEARBY (THE SAME
 I REMEMBER WHILE READING THIS I FELT HOMESICK NOW!
 (NOW I FEEL HOMESICK AGAIN FOR THIS PERIOD IN MY LIFE)

8:42 I AM UPSTAIRS WHEN I HEAR A VOICE SHOUTING:
 "A BAG" I FOUND A BAG HERE!"
 I YELL...... IT IS MY BAG. THE WOMAN (MUSEUM / MANAGER)
 IS RELIEVED, SHE WAS AFRAID IT WAS A BOMB OR
 SOMETHING LIKE THAT..... SHE HAS TO MOVE ON BECAUSE
 THE VIDEO'S IN THE MUSEUM ARE NOT RUNNING PROPERLY

8:52 HEAVY FOOTSTEPS OF A VERY BIG MAN.
 SOUND IT IS "SECURITY" WEARING A GREY SUIT.
 A SUIT DESIGNED NOT TO LOOK LIKE A UNIFORM
 ON HIS CHEST ONE CAN SEE A SILVER "V" (V= VEILIGHEID
 HE INSPECTS ALL DARK CORNERS AND BEHIND SECURITY IN
 DOORS. "JUST IN CASE" HE TELLS ME. DUTCH

8:58 ANNE (MARIE) THE P.R. PERSON COMES TO
 GET ME BECAUSE THE MUSEUM OPENS AT NINE.
 (THEY HAVE MORE THAN 1 MILLION VISITORS
 EACH YEAR AND ON BUSY DAYS 3000 PEOPLE!)

9:18 STANDING OUTSIDE. THERE IS ALREADY A
 HUGE LINE MOSTLY PEOPLE IN SHORTS (BRR)
 AND BACKPACKS ON THEIR CHEST, CAMERA'S
 AND COMFORTABLE SHOES.

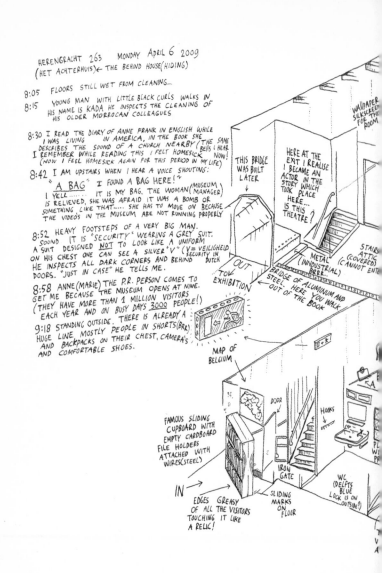

WALLPAPER
SILKSCREEN
FOR THIS
ROOM

THIS BRIDGE
WAS BUILT
LATER

HERE AT THE
EXIT I REALISE
I BECAME AN
ACTOR IN THE
STORY WHICH
TOOK PLACE
HERE...
IS THIS
THEATRE?

OUT

TO
EXHIBITION

METAL
ATTIC
(INDUSTRIAL)
BRRR

STAIRS
ATTIC
(COVERED)
(CANNOT ENTE

BRIDGE OF ALUMINUM AND
STEEL. HERE YOU WALK
OUT OF THE BOOK

MAP OF
BELGIUM

FAMOUS SLIDING
CUPBOARD WITH
EMPTY CARDBOARD
FILE HOLDERS
ATTACHED WITH
WIRES (STEEL)

DOOR

HOOKS

IRON
GATE

WC
(DELFTS
BLUE
LOCK IS ON
OUTSIDE!)

IN →

EDGES GREASY
OF ALL THE VISITORS
TOUCHING IT LIKE
A RELIC!

SLIDING
MARKS
ON FLOOR

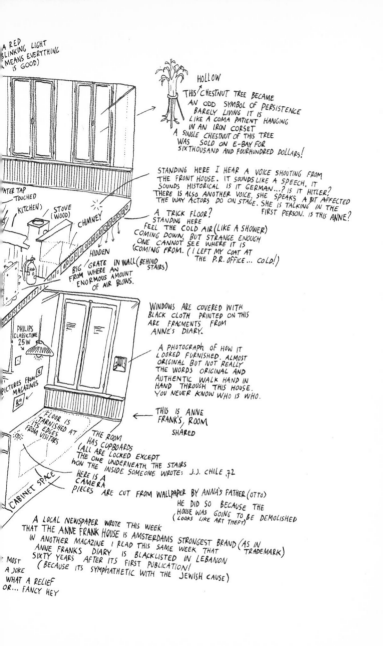

A RED
BLINKING LIGHT
(MEANS EVERYTHING
IS GOOD)

HOLLOW

THIS CHESTNUT TREE BECAME
AN ODD SYMBOL OF PERSISTENCE
BARELY LIVING IT IS
LIKE A COMA PATIENT HANGING
IN AN IRON CORSET
A SINGLE CHESTNUT OF THIS TREE
WAS SOLD ON E-BAY FOR
SIXTHOUSAND AND FOURHUNDRED DOLLARS!

WATER TAP
(TOUCHED)

KITCHEN)

STOVE
(WOOD)

CHIMNEY

HIDDEN

STANDING HERE I HEAR A VOICE SHOOTING FROM
THE FRONT HOUSE. IT SOUNDS LIKE A SPEECH. IT
SOUNDS HISTORICAL IS IT GERMAN...? IS IT HITLER?
THERE IS ALSO ANOTHER VOICE, SHE SPEAKS A BIT AFFECTED
THE WAY ACTORS DO ON STAGE. SHE IS TALKING IN THE
FIRST PERSON. IS THIS ANNE?

A TRICK FLOOR?
STANDING HERE
FEEL THE COLD AIR (LIKE A SHOWER)
COMING DOWN, BUT STRANGE ENOUGH
ONE CANNOT SEE WHERE IT IS
(COMING FROM. (I LEFT MY COAT AT
THE P.R. OFFICE... COLD!)

BIG GRATE IN WALL (BEHIND
FROM WHERE AN STAIRS)
ENORMOUS AMOUNT
OF AIR BLOWS.

WINDOWS ARE COVERED WITH
BLACK CLOTH PRINTED ON THIS
ARE FRAGMENTS FROM
ANNE'S DIARY.

PHILIPS
CLASSICTONE
25W

A PHOTOGRAPH OF HOW IT
LOOKED FURNISHED. ALMOST
ORIGINAL BUT NOT REALLY
THE WORDS ORIGINAL AND
AUTHENTIC WALK HAND IN
HAND THROUGH THIS HOUSE.
YOU NEVER KNOW WHO IS WHO.

PICTURES FROM
MAGAZINES

THIS IS ANNE
FRANK'S ROOM
SHARED

FLOOR IS
TARNISHED AT
ITS EDGES
FROM VISITORS

THE ROOM
HAS CUPBOARDS
(ALL ARE LOCKED EXCEPT
THE ONE UNDERNEATH THE STAIRS
ON THE INSIDE SOMEONE WROTE: J.J. CHILE .72
HERE IS A
CAMERA

CABINET SPACE

PIECES ARE CUT FROM WALLPAPER BY ANNA'S FATHER (OTTO)

HE DID SO BECAUSE THE
HOUSE WAS GOING TO BE DEMOLISHED
(LOOKS LIKE ART THEFT)

A LOCAL NEWSPAPER WROTE THIS WEEK
THAT THE ANNE FRANK HOUSE IS AMSTERDAMS STRONGEST BRAND (AS IN
IN ANOTHER MAGAZINE I READ THIS SAME WEEK THAT TRADEMARK)
ANNE FRANKS DIARY IS BLACKLISTED IN LEBANON
MOST SIXTY YEARS AFTER ITS FIRST PUBLICATION!
A JOKE (BECAUSE ITS SYMPHATHETIC WITH THE JEWISH CAUSE)
WHAT A RELIEF
OR... FANCY HEY

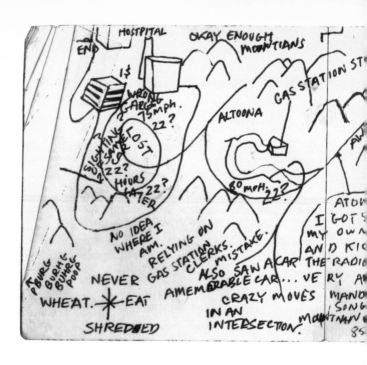

SUPREMELY ↑
→
LOST ↓

CHRISTIAN HERR

Christian drew this map while explaining to his grandmother how he got lost using Google Maps. He was on his way to visit his grandfather in the hospital following Google directions he had printed out. One wrong turn, however, and the directions became useless. The "point of confusion," Bedford, is indicated on the map. Christian began to draw the map on a Sweet'N Low package before his grandmother found him an old notepad instead. On another page in the notepad, Christian drew himself proper directions home from the hospital through Tire Hill, Pennsylvania, to the Pennsylvania Turnpike, then back to his home in Lancaster, Pennsylvania.

SOUTHWESTERN PENNSYLVANIA

MILLION, DIRECTIONS. TO HECK WITH GOOGLE MAPS

THIS IS WHERE IT GETS FUZZY, BIGTIME.

220?

219

220?

E?

30 W?
? 30 ? 220?

30 . which WAY?
?

30 N?

30
30?
220
W? 220

THE POINT OF CONFUSION, BEDFORD.

FIC
ON
E

85 MPH
76

LH+BURG

WESTERN PA WHERE THE FUN BEGINS.

CONT.

GOOGLE SAYS 3.25 HRS. REAL TIME 5 YEARS!

DONT KNOW WHAT THIS IS.

76

SUSQUEHANNA

HARRISBURG

283

LANCASTER

SMOOTH SAILING

WESTWARD

PROPER WAY HOME.

FRANKLIN ST.
403 to tire hill - DAVIDSVILLE
 TO
 SOMERSET
 THEN
 TURN PIKE

TIRE HILL, PA

HOSPITAL P.GARAGE

403

FRANKLIN ST.

THAT
EASIE̶R̶
EASYE̶

COFFEE

DAMN YO

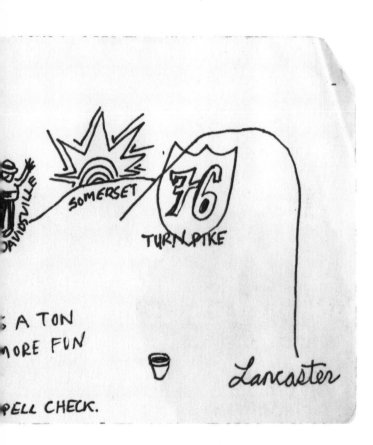

AVIDSVILLE

SOMERSET

76

TURNPIKE

Lancaster

; A TON
MORE FUN

PELL CHECK.

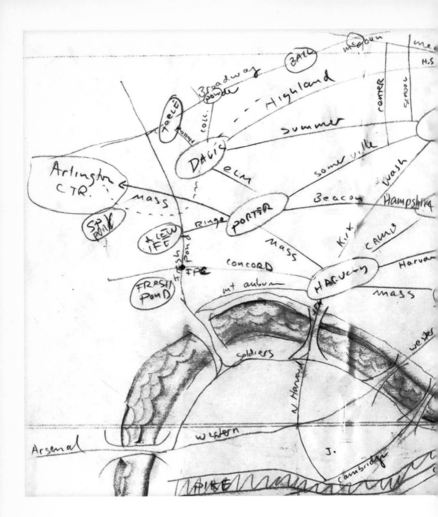

SQUARES

MAX HARLESS

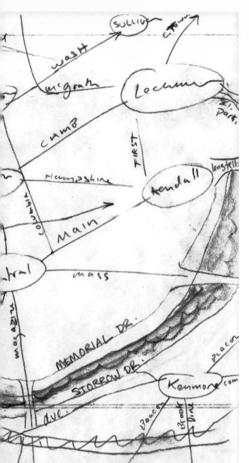

Max's map of Boston is organized by neighborhood. This drawing was a preliminary sketch for the final work. He scribbled this draft in 2005 to explain his idea of mapping Boston based on its squares and their connections. Boston, unlike many major American cities, is laid out in a network of connected, named squares, a feature that many mass-market city maps fail to emphasize. Max called the final product, which presents the city the way locals navigate it, *Unmapped Boston*.

BOSTON, MASSACHUSETTS

EXPLANATORY MAPS

← FIXED ORIGIN

SPIRALING TIME

DORATHY LYE

This drawing documents an unusual workday for Dorathy. She left for work in downtown San Francisco that morning and spent the next twenty-four hours running around the city. The lines on the map represent the places she went throughout the day, the different modes of transportation she used, and the time she spent. Her approach resembles a meditation on the various structures governing our daily lives. She considers the map as commentary on the regimentation of life bound by routine.

SAN FRANCISCO, CALIFORNIA

REMEMBERED ↓ MAP OF A CHILDHOOD WORLD

CHRIS COLLIER

Chris made this map in March 2009 after receiving an email from a childhood friend who invited him to a reunion of his close-knit group of school friends. After reading the email, Chris began to reminisce and created this drawing, which documents a typical weekend of his youth spent together with his friends running around the countryside, searching for ghosts or panthers in the woods, and climbing haystacks. He writes:

> I've never felt anything like that since, the joy of it all, and having such amazing friends to share it with. I'll never forget those days: building dens, skimming stones, talking about love; summer nights spent lying on the hilltop watching shooting stars and listening to the lions from the zoo roaring in the valley below.

SOUTH CAMBRIDGESHIRE, ENGLAND

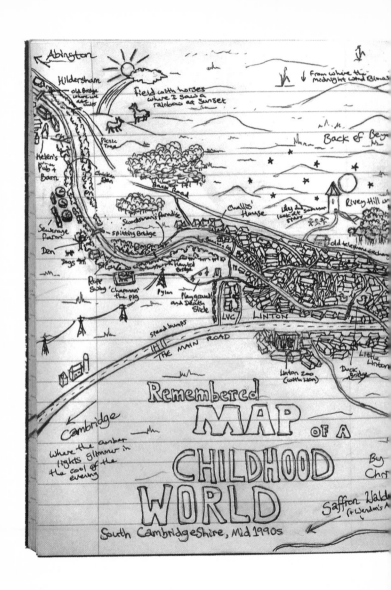

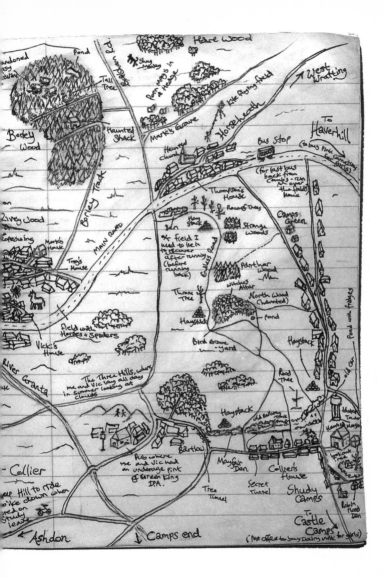

EXPLANATORY MAPS

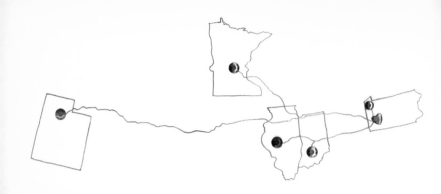

↑ BACK HOME

ALLISON LACHER

Allison's map charts the roads she took from different homes to travel to her hometown in Pennsylvania over the course of a year.

VARIOUS U.S. STATES

↓ SPIRALS

JEFF WOODBURY

This is a map of every place Jeff lived before moving to New York City. The map began with a single dot in Boston. From there, Jeff added a new ring for each new home. The right-most dot represents England, and the left-most, Hawaii. He lived in places such as Iowa, Monterey, and Vermont multiple times, indicated by a new dot that touches the outermost rings of the previous dot.

VARIOUS LOCATIONS

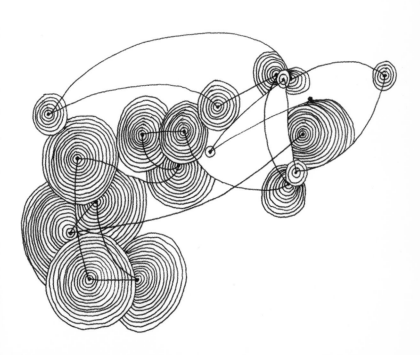

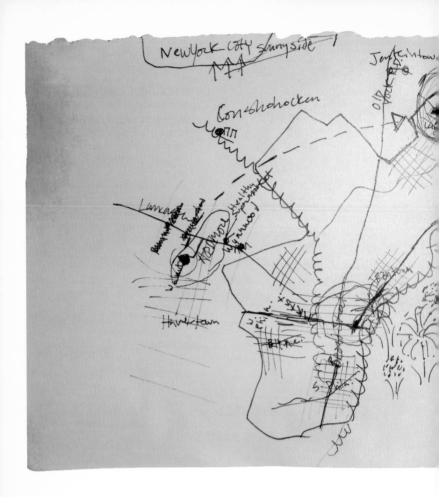

HAPPY NEW YEAR

SARAH HUNTER

Sarah drew this map on New Year's Day 2009 at two in the morning, while drinking whiskey, watching *Columbo*, and feeling unhappy. Her drawing shows all the places she would rather have been instead of her home in Ardmore, Pennsylvania. The map centers on Philadelphia, but also refers to England, New York City, and the fireworks she watched on television.

PHILADELPHIA, PENNSYLVANIA

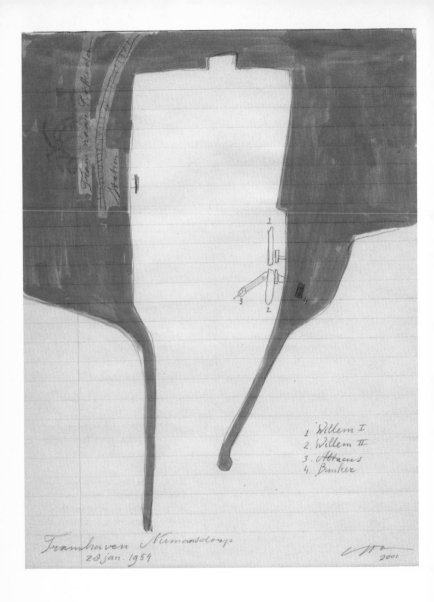

1 Willem I
2 Willem II
3. Attacus
4. Bunker

Tramhaven Numansdorp
28 jan. 1954

2001

← NUMANSDORP

KEES TOUW

In this map, Kees, an artist from Rotterdam, reconstructed his nomadic childhood on the waterways of 1950s Europe. Throughout his life, his parents ran a cargo ship, the *Attacus*, sailing the rivers and canals of Belgium, France, and the Netherlands. Kees spent the first eight years of his life traveling with his family. Specifically, this map refers to a place where the cargo ship was trapped in ice. The situation became dangerous, and the ship was rescued by the *Willem II*, one of a pair of secret escape ships for the Dutch government and the Royal Family. The drawing holds additional significance for Kees because it was during this period of time that his parents decided Kees should go live with his aunt and attend school in Rotterdam. The bunker on the map (labeled No. 4) is an old German bunker where Kees and other local boys played.

ROTTERDAM, THE NETHERLANDS

MIDDLE SCHOOL ↓ MAPS

SHAWNA GAMBOL WOODARD

These two maps, *Indian Tribes in the Ohio Regions about 1750* and *Early Settlements in Ohio*, were drawn by Shawna when she studied the state in the seventh grade. The maps include details such as the Western Reserve and the Virginia Military District, land that was set aside for Connecticut and Virginia, respectively, after the American Revolution, as well as the Seven Ranges, the first district in the Northwest Territory opened to settlement.

OHIO

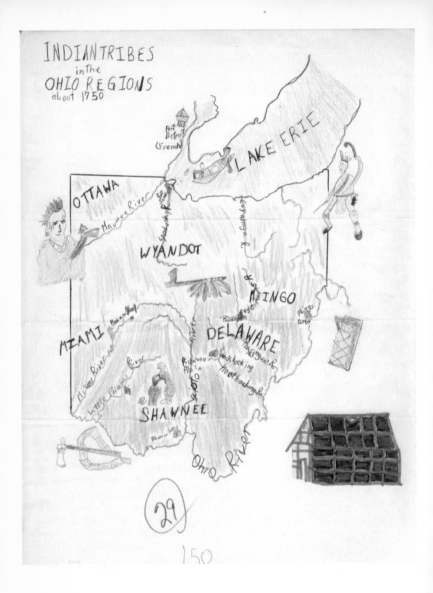

INDIAN TRIBES
in the
OHIO REGIONS
about 1750

Fort Detroit (French)

LAKE ERIE

OTTAWA

Maumee River

Sandusky River

Cuyahoga R.

WYANDOT

MINGO

Muskingum River

MIAMI

Beaver River

DELAWARE

Miami River

Little Miami River

Pickaway Plains

Scioto River

Hockhocking R.

Hockhocking R.

Hocking River

SHAWNEE

Shawnee Tn.

Mingo Bottom

Ohio River

29

150

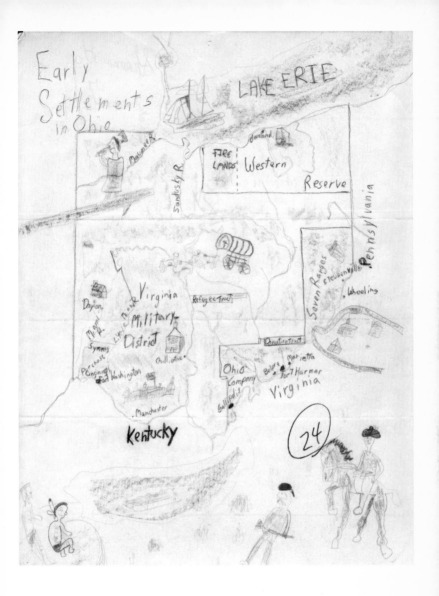

Early Settlements in Ohio

LAKE ERIE

Maumee R.

Sandusky R.

FIRE LANDS

Cleveland

Western

Reserve

Pennsylvania

Seven Ranges

Steubenville

Wheeling

Virginia Military District

Refugee Tract

Dayton

Mad R.

Little Miami R.

Symms Purchase

Cincinnati

Fort Washington

Chillicothe

Manchester

Congress Tract

Ohio Company

Gallipolis

Bedford

Marietta

Fort Harmar

Virginia

Kentucky

24

WHERE IS FISHTOWN?

WILL HAUGHERY

This map attempts to solve a common dilemma in a city: the question of where exactly the borders between different neighborhoods are. Will made this drawing shortly after moving to Fishtown, a neighborhood in Philadelphia. While sitting at a Chinese restaurant, he created the map during a conversation with a group of friends who were trying to decide which streets represented the border between Fishtown and its neighbor, Kensington.

PHILADELPHIA, PENNSYLVANIA

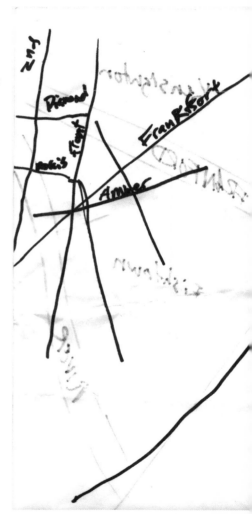

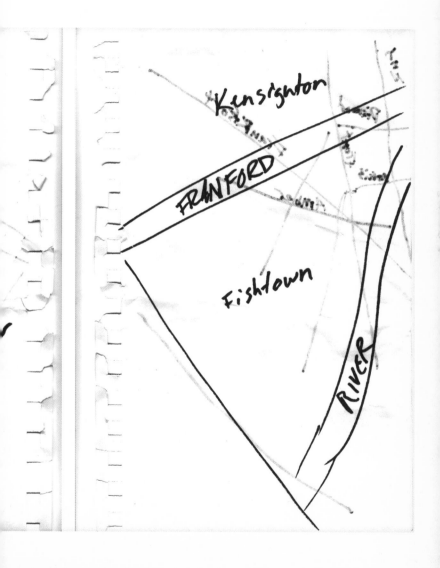

THIS IS NOT ACCURATE

WILL HAUGHERY

Will's other map of Philadelphia shows his two favorite neighborhoods, Fishtown and Northern Liberties. A truly personal account of the city, his drawing explains the urban environment based on personal interests and interpretations. These immediate, empirical observations are layered on top of a condensed geography of Philadelphia.

PHILADELPHIA, PENNSYLVANIA

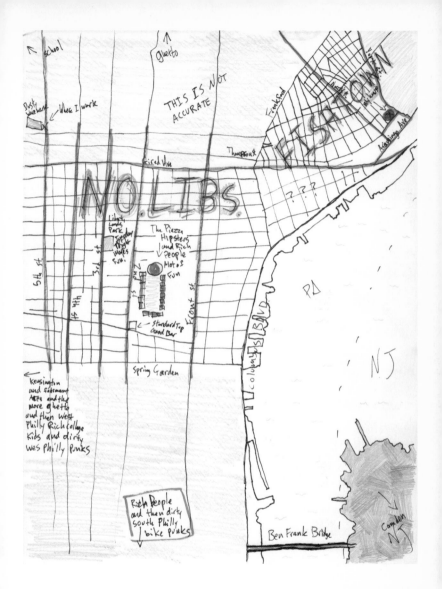

EXPLANATORY MAPS

↑ POLICE CHASE

TONY GONZALEZ

This map, drawn on a Post-it note, traces a particularly outrageous police chase that grabbed the attention of people living in the Tree Streets neighborhood of Waynesboro, Virginia. Tony, a reporter for the *News Virginian*, was just getting ready to leave the office, when a call for a pursuit came across the police scanner. He listened as the driver led police around the area. One of his coworkers witnessed part of the chase and drew this map to show where he was standing when the chase came around a corner.

WAYNESBORO, VIRGINA

↓ WAR

STEPHEN ABBOTT

Stephen drew this map on an index
card in August 2008 to explain to his
grandmother where the war between
Russia and Georgia had occurred.
Stephen also marked areas his family
had visited. He colored in Albania,
where his uncle had traveled a few
times, and marked Klagenfurt, Austria,
where Stephen had stayed fifteen
years earlier.

EUROPE

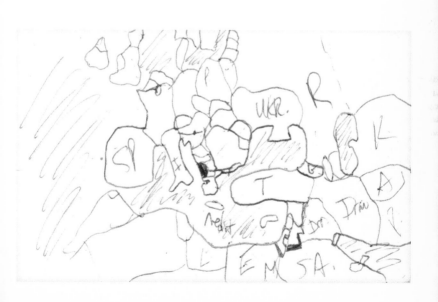

CROSS ↓ COUNTRY
DAN LEHMAN

Dan's map was used to prepare for a cross-country bike trip that he and three of his friends made in the summer of 2009. The large "X" over Colorado indicates that it may not be the best place to cross the Rocky Mountains. The map also marks steep mountains in California, the Great Salt Lake Desert in Utah, and cities of interest along the way.

UNITED STATES

MY WORLD →
ADRIAN MURPHY

Adrian has been asking strangers to draw maps of the world since 2005. His collection shows that most people represent the world in a common way: a circle that marks the boundary between the Earth and outer space. Beyond this line, things become much less familiar and outside the realm of our tangible, everyday experiences. The maps shown here were drawn by David M., David P., Denise, Dennis, Doug, Fiona, Joel, Lucian, and Toshiko.

COLLECTED IN IRELAND, SCOTLAND, ENGLAND, AND JAPAN

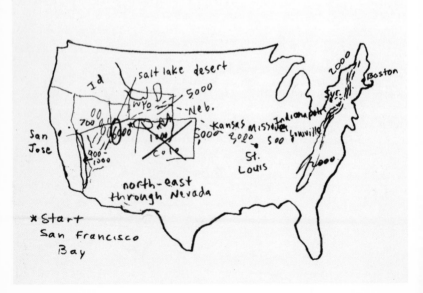

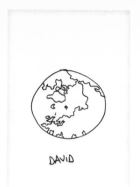

DAVID

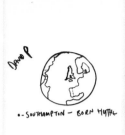

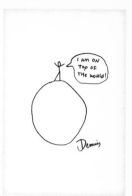

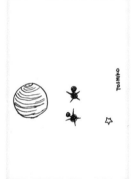

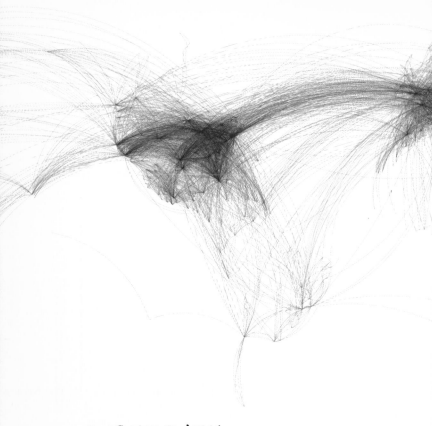

FLIGHT PATH

BRUCE MAU AND THE INSTITUTE WITHOUT BOUNDARIES

This map was created for the Massive Change exhibition at the Vancouver Art Gallery, an exhibit designed by Bruce in collaboration with the Institute without Boundaries to explore the role design can play in addressing major world issues. Ilene Solomon, a student at the institute, traced the flight paths of Canada's three major air alliances in order to create an overall impression of the density of air traffic on a given day.

CANADA

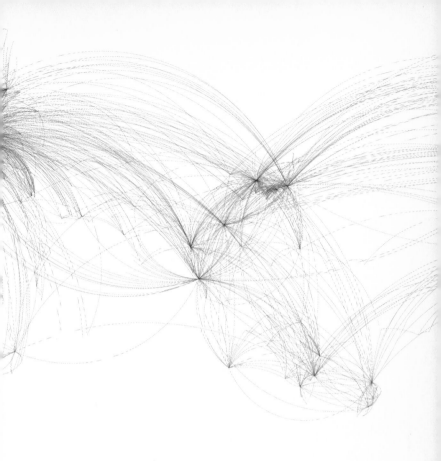

ENGLAND

STEPHEN THOMAS

Stephen drew this map of England in a notebook during a class in his first year at university. The drawing features details such as Stephen's home, the Queen's residence, and his personal belief that Wales looks like a pig's head. Ironically, at the time Stephen found the drawing among his papers, his parents were vacationing in the area bordered by the warning "Don't go here."

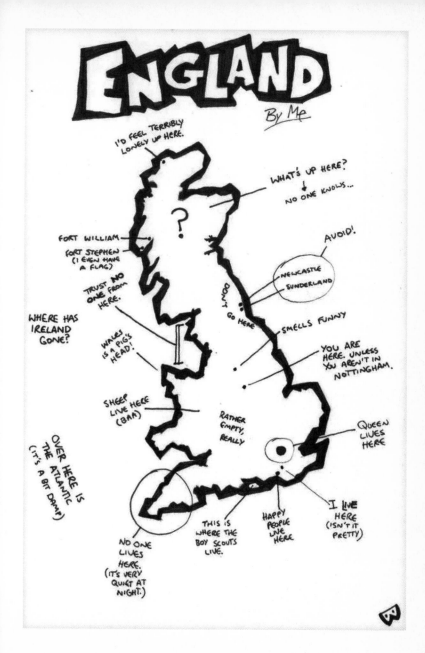

EXPLANATORY MAPS

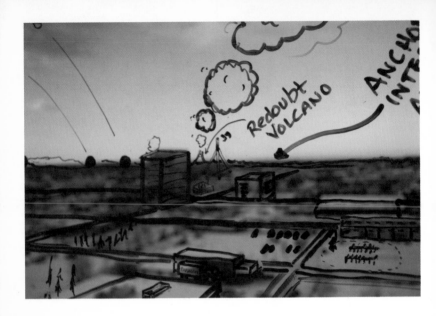

WINDOW ↑ →
CARTOGRAPHY

SCOTT GRIFFITH

Scott drew this map on the window of his thirteenth-floor office in midtown Anchorage. He was tracking the exact location of sunsets from his office when Mount Redoubt started erupting in March 2009. The maps include a perspective view of midtown locations around C Street and Northern Lights Boulevard and Scott's prediction of what the full eruption would look like.

ANCHORAGE, ALASKA

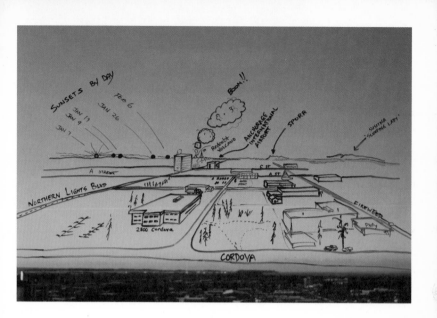

JALAN RAYA CELUK
SUKAWATI → BIRD PARK
 BARONG STATUE.

JAKARTA AREA
BUS STATION: LEFT (FROM UBUD.)

→ LEBAKBULUS → PARUNG

PASAR SENEN

 P20 BUS KORAJA

 2000 RP

ANY STATION.

JAN. 16/08 BOROBUDUR / AMANJIWO W/ T. TRICK.

UP 5:30 IN DPS / KENT BREAKFAST.
7am DPS AIRPORT. AIR GARUDA 600 RP → YOG
8:30am YOG TO BREAKFAST. MEET ARI + PWIK
 TRUCK DRIVER.
9:30am AUTO SPORTS BILLIARDS, MANAGED BY ARI,
 32 ONE KID. CUTE GIRL/WAITRESS SRI
 LESTARI.
12:00 PRAMBANAM W/ THE TWO GUYS.
2:00 LUNCH W/ TONI AT LITTLE WARUNG NEAR
 BATIK PLACE.
4 pm CHECK @ MANUHARA, AT BASE OF BOROBUDUR.
5 pm TOUR AMANJIWO! Even play gamelan w/
 BAND IN LOBBY. WINE w/ TRICK. Even
 blogging.

LOCATION AND SCALE

JEFF WERNER

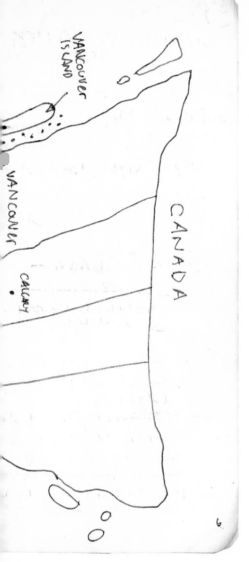

Jeff drew this sketch in his notebook during a bike trip across Java, Indonesia. Many people he met, especially in rural areas, had a difficult time placing Canada or North America on a map. He would use this sketch to help explain where he was from.

CANADA

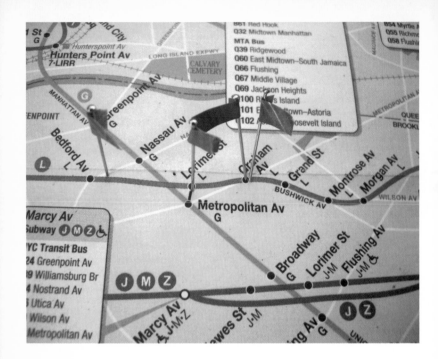

MISSED ↑ →

CONNECTIONS

INGRID BURRINGTON

Ingrid maps the locations of missed connections postings she finds on Craigslist. She is fascinated by the way they turn brief moments between strangers into something dramatic. In an attempt to find out if certain areas have a higher percentage of missed connections than others, she records the location of the postings she reads on an MTA subway map. On this map, the yellow flags stand for men seeking men, the pink for women seeking men, and the green for men seeking women (in three weekends, she found no women seeking women listings). The subway map thus becomes a diagram of twenty-first century drama, performed on a daily basis in the theater that is the Internet.

NEW YORK CITY, NEW YORK

EXPLANATORY MAPS

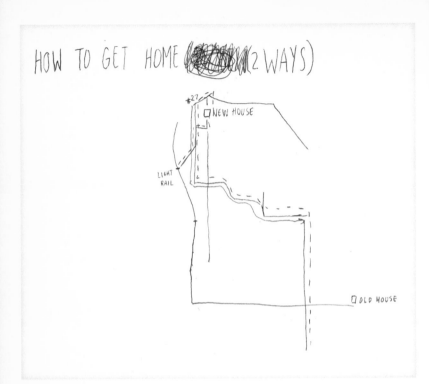

HOW TO GET HOME (~~scribbled out~~ 2 WAYS)

#27
□ NEW HOUSE

LIGHT RAIL

□ OLD HOUSE

↑ HOW TO GET HOME

INGRID BURRINGTON

Ingrid drew this map to explain the way home to her new house. The drawing includes both her old home and her new home, which is nearer to the same stop on the light rail.

BALTIMORE, MARYLAND

↓ ROOFTOPS

STUART HARRISON

Stuart drew this map of Melbourne's growing culture of rooftop bars and venues, concentrating on the northeast section of the city. He also included a few key landmarks and some other ground-based bars.

MELBOURNE, AUSTRALIA

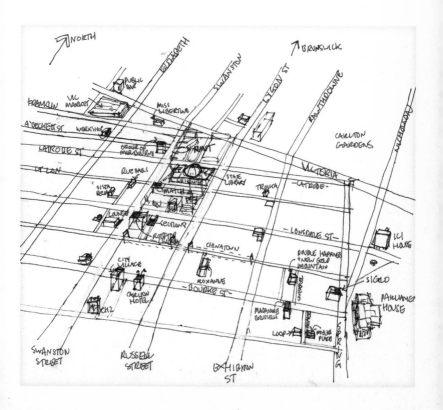

PARKS AND PLAYGROUNDS IN HAMPDEN

JOHANNA BACHMAN

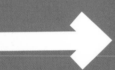

Johanna's map indicates parks
and playgrounds in the Hampden
neighborhood of Baltimore. The
letters at the top of the map refer
to Falls Road, Roland Avenue, and
Keswick Road; on the left are Cold
Spring Road, Forty-First Street, and
Thirty-Sixth Street. Johns Hopkins
University is located just to the right
of Wyman Park. If you find yourself
looking for green space in Baltimore
someday, this map could be useful.

BALTIMORE, MARYLAND

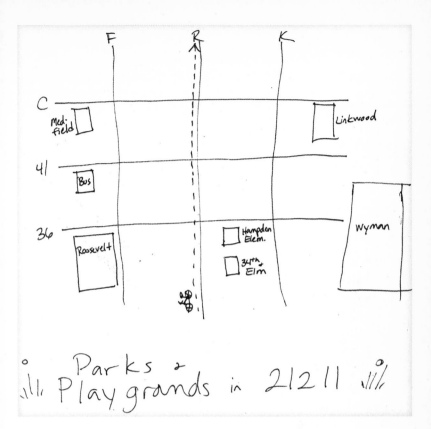

F R K

C

Medi-
field

Linkwood

41

Bus

36

Roosevelt

Hampden
Elem.

34th &
Elm

Wyman

Parks &
Playgrands in 21211

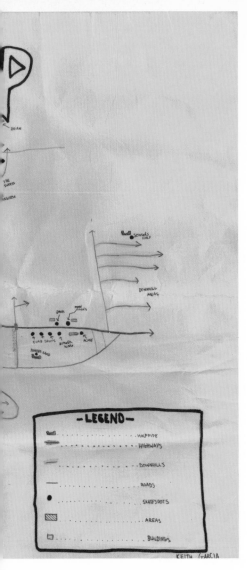

SKATE MAP OF DALLAS

KEITH GARCIA

Keith drew this map of Dallas, his hometown in northeastern Pennsylvania, in 1989, when he was thirteen years old. It highlights all the town's places to skate in wonderful detail. Keith recently rediscovered the drawing when he visited his parents and cleaned out his old closet.

DALLAS, PENNSYLVANIA

AFTERWORD

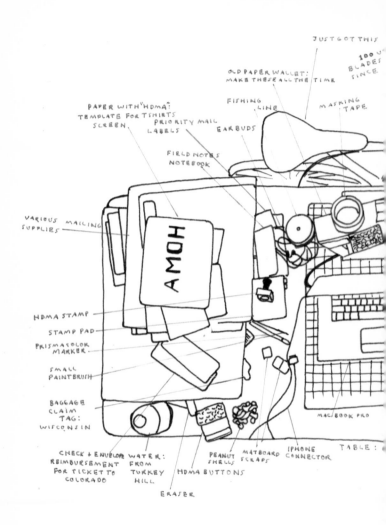

JUST GOT THIS

100 U...
BLADES
SINCE...

OLD PAPER WALLET:
MAKE THESE ALL THE TIME

FISHING
LINE

MASKING
TAPE

PAPER WITH "HDMA":
TEMPLATE FOR TSHIRTS
SCREEN

PRIORITY MAIL
LABELS

EARBUDS

FIELD NOTES
NOTEBOOK

VARIOUS MAILING
SUPPLIES

HDMA

HDMA STAMP

STAMP PAD

PRISMACOLOR
MARKER

SMALL
PAINTBRUSH

BAGGAGE
CLAIM
TAG:
WISCONSIN

MAC BOOK PRO

TABLE:

CHECK + ENVELOPE
REIMBURSEMENT
FOR TICKET TO
COLORADO

WATER:
FROM
TURKEY
HILL

HDMA BUTTONS

PEANUT
SHELLS

MATBOARD
SCRAPS

IPHONE
CONNECTOR

ERASER

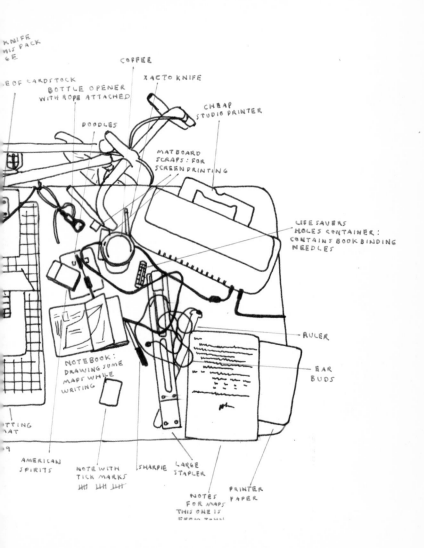

KNIFE
HIS PACK
...E

...E OF CARDSTOCK

BOTTLE OPENER
WITH ROPE ATTACHED

COFFEE

XACTO KNIFE

CHEAP
STUDIO PRINTER

DOODLES

MATBOARD
SCRAPS: FOR
SCREENPRINTING

LIFE SAVERS
HOLES CONTAINER:
CONTAINS BOOKBINDING
NEEDLES

RULER

EAR
BUDS

NOTEBOOK:
DRAWING SOME
MAPS WHILE
WRITING

...TTING
...AT

...9

AMERICAN
SPIRITS

NOTE WITH
TICK MARKS
IIII IIII IIII

SHARPIE

LARGE
STAPLER

PRINTER
PAPER

NOTES
FOR MAPS
THIS ONE IS
...

STUDIO TABLE

KRIS HARZINSKI

The vast majority of maps presented
in this book relate personal stories
that reveal glimpses of life's
processes. In conclusion, here is my
chance to share part of my own story,
as it relates to the Hand Drawn Map
Association and this book. This map
depicts the place where this book
was created, my studio. The table
where I spend most of my time writing
is a messy landing pad for the bits
and pieces of various projects. The
diagram shows my desk as it looked
on June 24, 2009, as I was nearing
completion of this work.